IMAGES OF ASIA

The Japanese Kimono

Series Editors, China Titles:
NIGEL CAMERON, SYLVIA FRASER-LU

The Japanese Kimono

HUGO MUNSTERBERG

HONG KONG
OXFORD UNIVERSITY PRESS
OXFORD NEW YORK
1996

Oxford University Press

Oxford New York
Athens Auckland Bangkok Bombay
Calcutta Cape Town Dar es Salaam Delhi
Florence Hong Kong Istanbul Karachi
Kuala Lumpur Madras Madrid Melbourne
Mexico City Nairobi Paris Singapore
Taipei Tokyo Toronto

and associated companies in
Berlin Ibadan

Oxford is a trade mark of Oxford University Press

First published 1996
This impression (lowest digit)
1 3 5 7 9 10 8 6 4 2

Published in the United States
by Oxford University Press, New York

British Library Cataloguing in Publication Data
available

Library of Congress Cataloging-in-Publication Data

Munsterberg, Hugo, 1916–
The Japanese kimono / Hugo Munsterberg.
p. cm. — (Images of Asia)
Includes bibliographical references and index.
ISBN 0-19-587511-7
1. Kimonos—History. 2. Textile fabrics—Japan—History.
3. Textile design—Japan—History. I. Title. II. Series.
GT1560.M76 1996
391' .00952—dc2095-41161
CIP

Printed in Hong Kong
Published by Oxford University Press (China) Ltd
18/F Warwick House, Taikoo Place, 979 King's Road,
Quarry Bay, Hong Kong

Contents

To my grandchildren:
Ephraim, who has always loved pattern,
Aryeh, who has always loved costume, and
Rachel, who has always loved colour.

Acknowledgements

This book would not have been possible without the work of my Japanese colleagues, to whom I am indebted for much of the scholarly information contained in these pages. To them, especially Mr Jo Okada and Mr Tomoyuki Yamanobe of the Tokyo National Museum, I offer my heartfelt thanks. I also am deeply indebted to Professor Edward Seidensticker for his excellent translations of *The Tale of Genji* and the works of Tanisaki.

For help in the research and preparation of the manuscript for publication, I would like to thank my assistant, Victoria Hoffman, and my daughter, Marjorie Munsterberg. Deirdre Donohue, of the Costume Institute, the Metropolitan Museum of Art, assisted with contemporary designers. Professor Alfred Marks helped with questions concerning the kabuki and Noh. Museum curators and private collectors were generous in making photographs available. Harumi Yaguchi, of the Tokugawa Art Museum, Nagoya, and Jean Mailey, of the Metropolitan Museum of Art, Robert Moes, of the Brooklyn Museum, Rand Castille and Erica Hamilton Weeder, of the Japan Society, and Ronnie Neuer, of the Ronin Gallery, all in New York, were especially kind.

HM
New Paltz, New York

1

The Early History of Japanese Textiles

IN NO OTHER CIVILIZATION, with the possible exception of ancient Peru, have textile arts played as important a role as they have in traditional Japan. That weaving already was esteemed in ancient times is indicated by the earliest Japanese chronicle, the *Nihongi* (Chronicles of Japan) compiled in AD 720, which speaks of the sun goddess Amaterasu, the most revered of deities, weaving garments for the gods. It also reports that as early as the third century AD, Emperor Ojin, son of the semi-legendary Empress Jingo (c.169–269), sent an emissary to the Paekche Kingdom on the Korean peninsula, and as a result Korean weavers of the Hata clan migrated to Japan. According to tradition, Empress Jingo first brought Chinese silk to Japan at the same time. Alternatively, it is said that the legendary princess Sotori-hime introduced silk weaving in the fifth century, and she is often represented either weaving or holding a shuttle in her hand. Other accounts in the *Nihongi* tell of the fifth-century Emperor Yuryaku (r.456–79) bringing craftsmen from China to Japan. It is believed that these were the ancestors of the weavers responsible for the founding of the Japanese textile industry.

Numerous legends connect the textile arts to Shinto and Buddhist deities. It is an ancient custom to dedicate pieces of cloth at Shinto shrines to the deities. The earliest record of such an offering is in the *Nihongi*, which dates it to the year 675. These gifts, often of fine quality, were preserved as sacred treasures, made into priestly garments, or used in decorating the shrines or in the mounting and framing of sacred pictures. Common people used more ordinary cloth for the same sort of offering. The custom continues

1

today, as when prayer offerings written on paper are put in trees and bushes all around a shrine.

The great value attached to the design and production of beautiful garments is made evident by the involvement in textile design of some of Japan's most famous artists. Most outstanding among these was the great eighteenth-century Rimpa school artist Ogata Korin (1658–1716), who is known to have personally designed and decorated kimonos, the loose, wide-sleeved robe which is the most common, and characteristic, form of Japanese clothing. Several of Korin's kimonos have survived. Other painters of the Edo period (1615–1868) who worked in this field are Maruyama Okyo (1733–95), the founder of the Realist school, and the Kano school painter Kuzumi Morikage (1620–90), who was noted for his use of resist dyes. Above all, it was the painters and printmakers of the Ukiyo-e school who depicted the latest fashions in their woodcuts. Some of these artists, such as Katsugawa Shunsho (1726–92) and Ando Hiroshige (1797–1858), decorated garments with their own designs. Kimonos attributed to them still exist. Originally there surely were many more.

How much textile artists are still revered in Japan is best indicated by the award of the title *Ningen kokuho*, Intangible Cultural Asset or, more popularly, Living National Treasure, to those deemed assets to the national heritage. Established in 1954, the honour was bestowed on no fewer than seven weavers and dyers. They were given a life stipend by the government and enjoy great fame for being so designated. Indeed, some of these craftsmen are better known and more highly regarded than all but a few painters and more so than any sculptors, a situation very different from that in any Western country.

While in most countries the wealth and taste of a person are evident through the jewellery worn by them, in

Japan the same money is spent on splendid garments made of the choicest fabrics and designed by outstanding craftsmen. The high esteem shown for textile arts explains the willingness to spend large sums on fine kimonos and the decorative sash, called the obi, that accompanies them. As much as US$100,000 has been asked for a particularly elaborate garment by a famous textile artist, and spending US$10,000 for a complete outfit is relatively standard. Even ordinary kimonos worn by young women at festive occasions can cost anything between US$100 and US$1,000. Old robes, especially those worn by famous people or used in the Noh theatre, are highly valued. Some of the finest have been designated *Juyobunkazai*, Important Cultural Properties or National Treasures.

Moriguchi Kunihiko, the son of the Living National Treasure Moriguchi Kako (b.1909), a famous Kyoto Yuzen dyer, explained the value of a great kimono:

A fine kimono is an adornment like the jewels and furs worn by a European woman. Although the form of the garment never changes, a custom-made kimono is a courtier gown and also an original work by a creative artist. A splendid kimono is apt to be handed down from one generation to the next like a painting or a piece of jewelry. Kimonos are not created to seasonal fads, but are designed as raiment that will contribute to Japan's tradition of beauty (Adachi, 1973: 47).

The oldest surviving Japanese textiles come from the sixth century, during the Asuka period (AD 552–645), but it was not until the Nara period (AD 645–794) that a fully developed textile industry existed. Examples of these early fabrics are preserved in the Horyu-ji temple, Nara, and in the Shoso-in, the storehouse of artistic treasures at the Todai-ji temple, also in Nara. Whether products of Japanese looms or imports from China, in technique and design they

resemble Chinese prototypes of the Sui (AD 581–618) and Tang (AD 618–907) dynasties. Indeed, the relationship between Nara Japan and Tang China was so close that it is often difficult to distinguish imported works from Japanese imitations of Chinese models.

The Shoso-in collection is extensive, consisting of some 100,000 textile fragments. They vary enormously in size, purpose, and technique. Particularly fine are the brocades, called *nishiki*, which are brilliant in colour and design. Among the dyeing techniques, tie-dyeing, known as *kokechi*, the ancestor of the modern *shibori* technique, is the most remarkable. Another type of dyed cloth used a wax-resist technique, similar to batik. The fabric known as *kasuri* employs threads dyed before the weaving takes place. A splashed design, resembling the Indonesian *ikat*, results. This technique originated in India, and came to Japan by way of China. Two other fine kinds of cloth produced during the Nara period were a silk gauze, called *ra*, and *aya*, a silk damask made with a simple geometric motif on twilled ground.

These textiles are outstanding for their technical perfection as well as the beauty of their designs. They vary from simple geometric patterns to complex pictorial compositions taken from Chinese models. Some of the motifs derive from Persian and Western Asian sources, reflecting the cosmopolitan nature of this art. All kinds of floral and leaf forms are represented, as well as animals, birds, people, and divine figures. Most of these more elaborate compositions were used for hangings, screens, and banners, while fabrics for clothing usually display more simple patterns.

No complete garments have been preserved, but from priests' robes and paintings of the time, it is possible to reconstruct the style of dress of the Nara period. The best depiction appears in a famous painting of Kichijoten, the

goddess of beauty and good fortune, from AD 795 (Plate 1). It shows an elegant lady dressed in a loosely fitting blouse and a long skirt, decorated with four-lobed medallions and small lozenges, and a flowing scarf.

The rapid development and excellence of the textile industry during the Nara period greatly benefitted from government policies. In 701, a Bureau of the Palace Wardrobe was established in the Ministry of Central Affairs and an office of the Guild of the Needle was set up in the Ministry of the Treasury. There was a Palace Dyeing Office in the Imperial Household Ministry, in charge of the sewing and dyeing for the imperial family and the court. In addition, there was an office of the Guild of Needleworkers and the Guild of Weavers to oversee the textile trades. Experts were dispatched in 711 to local districts and the outlying provinces to teach craftsmen how to make silk, brocade, and twill.

The Nara period was followed by the long and culturally productive Heian period (794–1185). Although no Heian garments have survived, they are described vividly in contemporary literature and paintings. During the early Heian period (the century from 794 to 894), the Chinese fashions which prevailed during the Nara period apparently continued to be popular, while during the late Heian period (from 894 to 1185), often called the Fujiwara period, a more characteristically Japanese style of dress prevailed.

The famous novel *The Tale of Genji*, written around the year 1000 by Lady Murasaki Shikibu, contains numerous descriptions of the beauty of the garments worn by members of the imperial court in Kyoto. Choice of the proper garment was crucial:

For Murasaki, [Prince Genji] selected a lavender robe with a clean pattern of rose-plum blossoms and a singlet of a fashionable lavender. For his little daughter, there was a white robe lined

with red and a singlet beaten to a fine glow. For the lady of the orange blossoms, a robe of azure with a pattern of seashells beautifully woven in quiet colours, and a crimson singlet.... [Then] he sent around messages that everyone was to be in full dress. He wanted to see how well, following Murasaki's principle, he had matched apparel and wearer (Murasaki, 1976: 406).

Improper garments were ruinous:

When the colours of the robe do not match the seasons, the flowers of the spring and the autumn tints, when they are somehow vague and muddy, the whole affair is as futile as the dew (Murasaki, 1976: 30).

An entry from the diary of Lady Murasaki reports:

All the women were in their best that day, but two of them showed a want of taste when it came to the colour combination of their sleeves. As they brought in the food, they came in full view of the nobles and senior courtiers and were subject to stares. I later heard Lady Saisho had been scandalized. But it was not that much of a *faux pas*, just that the combinations were somewhat uninspiring (Murasaki, 1982: 151).

The main garments worn by male aristocrats during this period were the *noshi*, the official garb of court nobles, and the *kariginu*, a more informal dress for everyday use. Both are loose fitting, very large, with round collars and long sleeves which hang to the knees. An Edo period version of the *kariginu* jacket, decorated with crabs in a bamboo lattice basket, may be seen in the Tokugawa Art Museum, Nagoya (Plate 2). Long baggy trousers of the *hakama* type, resembling a divided skirt, often trailed behind the wearer (Figures 1.1 and 1.2). On ceremonial occasions, men wore the *sokutai*, which is still worn by male members of the

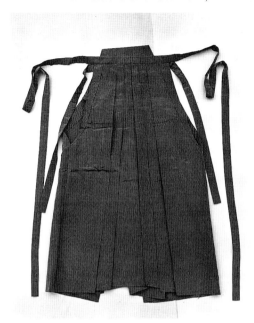

1.1 Pleated silk *hakama*, nineteenth century (Metropolitan Museum of Art, Gift of Mrs Howard Mansfield, 1950. 50.110.1c).

imperial family. It consists of two large, round-necked kimonos, one worn over the other, and very full *hakama* trousers resembling a skirt.

By far the most striking robe worn by Heian nobility was the court lady's *juni-hitoe*, or twelve-layer gown. Truly splendid attire, it at times consisted of as many as twenty different layers of cloth. A good example can be seen in the portrayal of the poetess Ko-Ogimi, from the scroll of the Thirty-six Immortal Poets (Plate 3). The level closest to the skin consists of a basic undergarment, over which lies a simple, unlined gown called *hita*. Next comes a set of lined robes of various colours and combinations, called *sugimi*. On that is a gown, often of crimson beaten silk, called a *uchiginu*, and over this a coat called *uwagi*, the lining of which protrudes beyond the surface of the sleeve

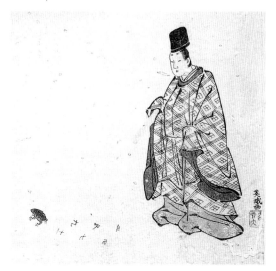

1.2 Woodblock print by Suzuki Harunobu (c.1725–70) showing tenth-century calligrapher Ono no Tafu (Ronnie Neuer Collection, New York).

openings. For very formal occasions, a long train, called a *mo*, and a jacket or *karaginu* might be added. For less formal occasions, these might be replaced by an outer robe referred to as *ko-uchigi*.

The material used for the *uwagi*, *mo*, and the *karaginu* was *orimono*, or figured silk, a general term employed for a variety of materials such as *nishiki*, *kanhate* (ribbed silk), *minimono* (embroidered silk), *aya*, and *katori* (taffeta). The lined robes usually were made of very thin materials, gauzes and gossamers, known by their generic name of *usomono*. Since the upper layers of these robes were often transparent, they let the lining shine through. New and subtle colour combinations resulted, often named after flowers. Fixed arrangements of the layered colours evolved, called *kasane no irome*. For example, in the pine layer, the two upper garments were dark and light sappan-wood red, while the three other gowns were increasingly darker shades of yellowish green, and the undergarment was vermilion. Each

colour scheme was carefully attuned to the occasion, the season, and the mood of the wearer (Tokyo National Museum, 1954: vol. V, p. 14).

During the Kamakura period (1185–1333), the military class came to power, the capital was moved out of traditional Kyoto, and elegant court life was replaced by a more restrained style of living. Laws restricted the extravagance of fashions, with the most elaborate dress reserved for warriors. Of the surviving garments, the most impressive are those, called *hitatare*, worn under armour. Good examples in the Tokyo National Museum and the Oyamazumi Shrine, Ehime Prefecture, suggest that brocades with floral designs, figured silks, and tie-dyed materials were popular.

The most important innovation during this period was the *kosode*, a narrow-sleeved kimono. Originally an undergarment of plain white cloth, it became a colourful, decorated main garment. By the end of the Kamakura period, the *kosode* and the *hakama* had become standard dress for court ladies. Generally speaking, Kamakura garments were plainer and simpler than in previous times, and the custom of the many-layered kimono was discontinued.

The Kamakura period was followed by the Muromachi period (1333–1573), also known as the Ashikaga period, when the national capital moved back to Kyoto. Splendid garments, dedicated to the shrine in 1390, are preserved in the Kyoto Museum and the Great Kumano Hayatama Shrine and are today listed as National Treasures. The garments held by the Kumano include seventeen different robes. Among them are examples of *akome*, a formal male court costume, *kariginu*, *ho*, an outer garment for court, *noshi*, and *hakama*. The material consists mainly of brocade and twill-weave silk. The colours are subdued and the decorations are largely floral designs and geometric patterns. It was during this age that the family crest became a popu-

lar ornamental feature. Garments with it are called *dai-mon*, the great crest.

Both the Kamakura and Muromachi periods saw the importation of fabrics from Song (960–1279) and Ming (1368–1644) dynasty China. Highly admired at the time, several still preserved today are referred to as *meibutsu-gire* (celebrated fabrics). The name comes from their having been used to wrap famous tea ceremony utensils. Among these fabrics were *kinran*, a plain-weave silk pattern made of paper thread covered with gold leaf, *donsu*, a striped silk damask with designs in satin as well as embroidery and dyed patterns, and *kanto*, silk woven in stripes with either a plain or a satin weave. Each of these fabrics exerted an important influence on the Japanese textile industry, which had been devastated by civil war and the destruction of Kyoto.

2

Garments of the Momoyama Period

IT WAS NOT really until the Momoyama period that Japanese craftsmen began to produce the bold, colourful textile designs for which they have become famous. Although the age was brief, lasting no more than five decades (1573–1615), it was one of the most brilliant and artistically productive in Japan's long history. Its spirit began to be felt by the middle of the sixteenth century and its influence continued to have a powerful impact on the art of the early Edo period, long after the Tokugawa shoguns had seized control of the country.

The secular arts of the Momoyama period were of unparalleled splendour. The magnificence of screen paintings, lacquers, ceramics, and, above all, textiles reflected the new prosperity of the country, once more united after a long period of division and civil war. They benefitted from the power and grandeur of the military rulers, and of the new wealth and importance of city dwellers, notably the merchant class, who had begun to be important patrons of art. The opening of Japan to outside influences, supported by the country's close relationship to Ming China, encouraged an atmosphere of change and freedom.

The recall of the weavers, who had fled Kyoto during the years of strife, shaped the art of this time. It was during this period that the Nishijin district was established as the centre of textile production, a position it occupies to this day. It is estimated that no fewer than ten thousand weavers worked in the Nishijin at this time, producing what were probably the finest textiles in the world. With this large pool of highly skilled craftsmen and excellent

designers, Japan was able to create both a huge quantity and a great variety of beautiful cloths. The silks and brocades were especially fine.

Foreign influence proved stimulating. Sixteenth-century records tell of the importation of European garments, which became fashionable among the upper classes, and of the admiration the Japanese had for textiles from Europe and from European possessions in India and South-east Asia. At the same time, bold, colourful textiles from Ming China, where the decorative arts flourished, proved inspirational. The port city of Sakai, today part of Osaka, and Hakata, now Fukuoka, in northern Kyushu, became centres of international trade with not only Portugal and China but also Macao, the Philippines, Thailand, India, Malaysia, and Persia.

Excellent examples of kimonos from this period have been preserved. Several of these garments are believed to have been worn by the great military rulers of the time, such as Nobunaga Oda (1534–82) and Hideyoshi Toyotomi (1537–98). Similar robes often were given to loyal retainers and outstanding Noh actors as indications of favour, or dedicated to Buddhist temples and Shinto shrines. In the rare event that one comes on the art market today, it brings an exorbitant price.

Contemporary genre paintings provide evidence of period styles of dress. The pictures clearly distinguish among the costumes worn by different classes, from the splendour of the gowns of the ruling class to the simple folk textiles worn by ordinary people. Particularly fine were the garments worn by actors, dancers, and high-class courtesans, as is shown in screen paintings from the first half of the seventeenth century. Other examples come from the opening years of the subsequent Edo period, when similar fashions prevailed. One six-part screen shows a dancing woman

2.1 Dancer, one part of a six-panelled screen, colours and gold on paper, seventeenth century (Suntory Museum of Art, Tokyo; photo courtesy the Japan Society, Inc., New York).

in each panel (Figure 2.1). That the artists would render the garments with such care is further indication of the great value attached to them.

The love of display and the grandeur of the Momoyama age found perfect expression in these magnificent garments. The spectacle of hundreds of courtiers dressed in them must have been overwhelming. The patterns were large and bold, in contrast to the smaller and more delicate ones of previous periods, and they never became lost in realistic detail, as was often the case in later centuries. Momoyama designers always kept a sense of the two-dimensional decorative pattern, a characteristic which supports the functional character of this art form.

Another appealing quality of these garments is the variety and inventiveness of their designs. The motifs usually

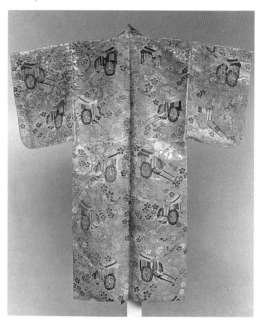

2.2 *Kara-ori* Noh robe, brightly coloured floss silks on gold ground, c.1600 (Metropolitan Museum of Art, Rogers Fund, 1919. 19.88.1).

come from nature, with floral forms particularly favoured, along with animals, birds, and aquatic creatures. One outstanding example is a Noh robe believed to date from about 1600 (Figure 2.2). Woven in brightly coloured floss silk on gold ground, it has designs of flowers, birds, and carts arranged in a repeated pattern. Another splendid Noh garment, in the Tokugawa Art Museum, Nagoya, shows medallions with floral designs against a ground of diamond shapes with blossom patterns (Plate 4). Particularly charming is a seventeenth-century Noh robe, decorated with iris designs (Plate 5).

Characteristic of the technical inventiveness of the age is the development of a new type of brocade known as *kara-ori*, which was used in the Noh robe with the flower and cart motif mentioned above. Although the term liter-

ally means 'Chinese weave', and was no doubt inspired by the multicoloured brocades imported from Ming China, it was a typically Momoyama product. The bright colours and rich use of gold and silver were dazzling, and the resulting visual effect lavish. It appeared with special frequency in robes designed for Noh actors playing female roles. Other particularly splendid cloths of the period were the gold and silk brocade *kinran* and *donsu*, a silk damask.

The most original technique invented during this period was *tsujigahana*, a process employed from the second half of the sixteenth century through the early part of the seventeenth century. It combines stitched tie-dyeing and painted designs outlined in ink. Garments using this fabric have mostly survived in fragments. Toshiko Ito, in a magnificent monograph on this technique, rightly calls it the flower of Japanese textile art (Ito, 1985: 2). Certainly it is the most original and unique of all the fabrics produced in Japan, with no equivalent either in Europe or the rest of Asia.

The most celebrated example of a garment executed with *tsujigahana* is an outer jacket, or *dofuku*, believed to have been worn by Hideyoshi himself. Dating from the end of the sixteenth century, it is today a National Treasure. On it, patterns of paulownia leaves and blossoms in the upper part of the garment and rows of arrows around the hem are striking, and the subdued and elegant colours are particularly fine. The colourful patterns were produced by delicate tie-dyeing with tiny stitches, demonstrating the great skill of the dyers. While the best of these kimonos were made for the nobles and rich merchants of Kyoto and Sakai, contemporary paintings show even common people wearing garments made with this technique. It appears that the more colourful and brighter garments were worn by men, while the more delicate patterns and subdued colours were worn by women.

The basic garment worn by both sexes now became the *kosode*, a term used interchangeably with kimono. Literally, *kosode* means 'small sleeves' and indicates that the garment has narrow sleeves, in contrast to the wider sleeves of the kimono. It was the width of the sleeve opening, however, which determined whether the kimono would be called a *kosode* or not. The *furisode*, for example, with its long swinging sleeves, was considered a *kosode*, since the lower part of the sleeve was sewn together. Most of the surviving Momoyama *kosode* were worn by Noh actors or were given to retainers by rulers. In both cases, generations of descendants have preserved them with great care, and even today they are often in fine condition.

Another type of kimono worn by the nobles of the Momoyama period was the *jimbaori*, a sleeveless short coat worn over armour during military campaigns. The most famous is said to have been worn by Hideyoshi and is today in Hideyoshi's temple in Kyoto, the Kodai-ji. It is a most remarkable textile, which reflects the international character of some Momoyama art. The representation of lions attacking bulls is an ancient Persian motif, while the lions and phoenixes recall Chinese animal symbolism. Particularly charming are the deer, which suggest similar animals in both Near Eastern and Chinese art. The weaving of the garment is similar to that of Gobelin tapestries, possibly indicating a European influence.

A further style of garment which became popular during the Momoyama period, and which continues to be used today, is the *uchikake*. A gown with long sleeves and a padded trailing hem, it was worn by court ladies over the kimono on formal occasions. One example, believed to have been worn by the wife of Hideyoshi, is now in the Kodai-ji collection. Dating from the late sixteenth century, it

shows tortoise shells arranged in a grid pattern, yellowish-green and purple in colour.

Today it is often difficult to be certain if a given garment was actually a product of Momoyama looms. Suffice it to say that for a period of one hundred years, from about 1550 to 1650, Japan experienced the golden age of its textile art. Weavers of the Nishijin district, under the inspired patronage of nobles and rich merchants, made works which all lovers of textiles regard as among the masterpieces of this art.

3

Garments of the Edo Period

THE EDO PERIOD, lasting more than 250 years, was named after the new seat of government, the city of Edo (modern Tokyo), where the Tokugawa shoguns had their capital. The period conveniently divides into three phases: early, from 1615 to the end of the seventeenth century; middle, the eighteenth century; and late, the final phase of the Tokugawa rule, from 1800 to the year 1868, when imperial power was restored and Japan was opened to the Western world.

The artistic style of the early Edo period represents a continuation of Momoyama art, so that it is often difficult to say if a given kimono should be called late Momoyama or early Edo. The emphasis on bold designs and gorgeous colours in fact culminated in late seventeenth century kimonos, famous for their richness and splendour. A good example is the handsome *kosode* decorated in tie-dye, embroidery, and gold leaf, in the Kanebo collection, Osaka. Bold designs of flowers contrast with a plain ground of white figured satin (Figure 3.1).

Technical innovations, especially in regard to dyeing, were introduced in the middle Edo period, and the spirit of that age differs from those that preceded it. The grandeur and boldness which marked the textiles of the seventeenth century gave way to more complex, sometimes even fussy, designs, often pictorial in character. Yet, the output continued to be rich and varied, despite attempts by the Tokugawa rulers to curtail expenditures on extravagant kimonos. Two excellent examples of middle Edo garments from the Kanebo collection clearly illustrate these new tendencies. A *kosode* with bridge, plum blossoms and water

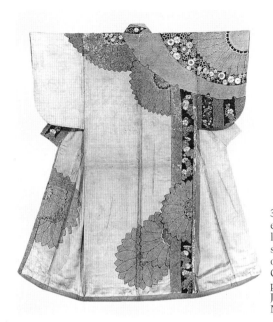

3.1 *Kosode*, tie-dye, embroidery, and gold leaf on figured white satin, early Edo period (Kanebo Collection, Osaka; photo courtesy the Japan Society, Inc., New York).

plantains (Figure 3.2) displays the greater complexity of the patterning, while a kimono with an autumn scene of falcons, maples, and waterfalls shows a tendency toward more pictorial designs (Figure 3.3). Another lovely example of a middle Edo robe is a *uchikake* in which a delicate all-over pattern of leaves and blossoms is executed by the use of embroidery, tie-dyeing, and weaving (Plate 6).

During the late Edo period, the art of the kimono began to decline. Some of the products of the era, especially in their detail and naturalism, surpass anything which had been made before. But the inspiration seems to be lagging, the patterns employed often repetitive and based on older models. As in the other arts of this age, this phase of Edo textiles represents the end of a great tradition rather than a new high. The only exceptions are in the folk fabrics

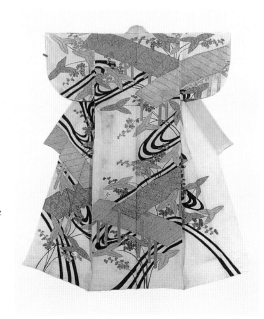

3.2 *Kosode*, tie-dye and embroidery on white silk crêpe, middle Edo period (Kanebo Collection, Osaka; photo courtesy the Japan Society, Inc., New York).

made for the common people, where new artistic energy can be found.

The most important technical innovation of this period was Yuzen dyeing, which used a rice-paste resist to create its effects. Yuzen dyeing is attributed to the late seventeenth century Kyoto painter Miyazaki Yuzen (?–1758). Little is known about him, and modern scholars think that he perfected and popularized the process rather than actually inventing it. The Yuzen technique gave artists freedom to render complex images, making it possible to achieve pictorial designs far more realistic than anything that had been attempted before. Yuzen dyeing also was used in combination with tie-dyeing and embroidery, resulting in ever more splendid and intricate designs. The most famous garment produced using this technique is the long-sleeved

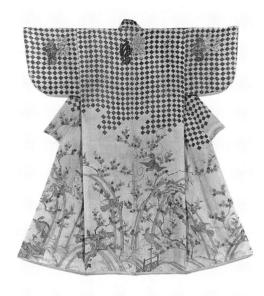

3.3 *Kosode,* resist-dye and embroidery, middle Edo period (Kanebo Collection, Osaka; photo courtesy the Japan Society, Inc., New York).

furisode with *noshi* design in the collection of the Yuzen Historical Society, Kyoto (Plate 7). It shows a bundle of strips of cloth arranged in a colourful and striking manner against a red background. Yuzen is here combined with tie-dyeing, embroidery, and silver foil, to create what is usually thought of as the single most accomplished garment of the middle Edo period.

An outstanding example of the more pictorial style of Yuzen dyeing during the late Edo period is a *kosode* showing the amusement centre of Edo, the Yoshiwara district (Figure 3.4). The cloth is treated almost as if it were a section of a hanging scroll or a screen painting, rather than the flat surface of a garment. The result is an illusionistic composition in which spatial depth and a wealth of details are rendered with great vividness. The gates and houses of

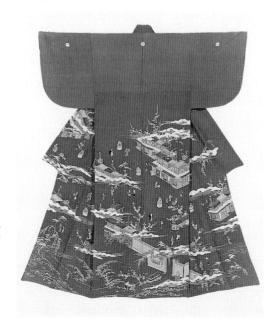

3.4 *Kosode*, resist-dye and embroidery on crêpe, late Edo period (Kanebo Collection, Osaka; photo courtesy the Japan Society, Inc., New York).

Yoshiwara are seen, with courtesans walking the streets accompanied by their servants and gentlemen visitors. Bamboo, willows, and flowering trees are clearly outlined. Both the subject and the style of the design resemble the woodblock prints of the Ukiyo-e school rather than the far more abstract surface patterns which previously had characterized Japanese kimono decoration.

Although developed by the artists of the Nishijin district for the elaborate robes of the well-to-do, Yuzen dyeing soon was used for all kinds of textiles. Knowledge of the technique spread to the provinces, notably Kaga, modern Ishikawa prefecture. The cloth produced there, known as Kaga Yuzen, was noted for its colourful, often gaudy, designs, featuring bright reds and greens. The Kaga dyers also were very fond of complex compositions of picturesque landscapes or scenes from Edo.

Related to Yuzen dyeing is a process known as *chaya-tsuji*, which also uses rice-paste resist but on material usually made with high-quality hemp. The colour favored by the *chayatsuji* dyers was indigo, and the designs generally were simpler than those employed in Yuzen. Garments decorated in this manner often were chosen for summer wear, since they were very light. They enjoyed particular popularity among the noble ladies of the Tokugawa court. The term *katabira* is applied to these unlined, light kimonos. A fine example of a child's *katabira* has bird and net designs (Figure 3.5). Here, the feeling for two-dimensional ornamental design is preserved, because the delicate detail is kept subordinate to the general pattern.

Even the most famous artists of the Edo period decorated kimonos. Among them were such eminent painters as Ogata Korin and Hoitsu (1761–1828), as well as several members of the Kano school. The printmakers of the Ukiyo-e school also had close connections to the textile industry. In fact, the founder of this school, Hosokawa Moronobu (1618–94), came from a family engaged in the textile business, and he was trained in this field. His son, after trying his hand at woodblock prints, decided to abandon printmaking and return to the traditional family business.

The most celebrated of the kimonos decorated by famous Edo artists are those by Korin, and the best-known example, now in the collection of the Tokyo National Museum, is a *kosode* showing hand-painted autumn plants on a white ground. A kimono with similar decoration, probably by an artist from the Korin school rather than by Korin himself, shows the so-called Three Friends of the Cold Season, the pine, the bamboo, and the plum blossom, painted on white silk (Figure 3.6).

The most striking development in dress style during the Edo period was the growing importance of the obi, the sash

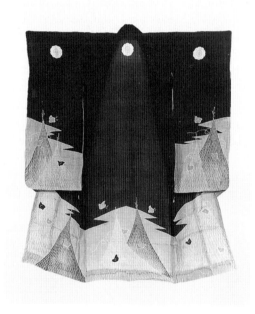

3.5 Child's *katabira* with *chayatsuji* dyeing, late Edo period (Kanebo Collection, Osaka; photo courtesy the Japan Society, Inc., New York).

worn around the waist. In earlier centuries, it had been a narrow band of no great consequence, but it became wider and more prominent after the mid-seventeenth century. Tradition has it that this was the result of the great fires of 1657 and 1661, when the short, narrow obis, which had been twisted and tucked in, came apart and were lost as women tried to escape the flames. It is also reported that a prominent kabuki actor of the time, Uemura Kichiya, appeared wearing a wide and long obi tied in a bow, which created such a sensation that it became an instant fashion. Whatever the reason, the obi became a primary part of Japanese dress. Both its width and its length increased and the end was tied in an elaborate knot, as may be seen in prints of elegant Edo period ladies (Figure 3.7).

Textile artists of the Nishijin district now made special

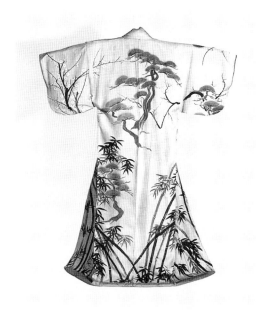

3.6 Kimono, decorated by Ogata Korin or a member of the Korin school, painted silk, late Edo period (Brooklyn Museum, Gift of the Hammer Foundation).

brocades designed as obi material, which might be as long as twelve feet and as broad as six to eight inches. In contrast to the fabric of the kimono itself, which was usually very soft, the obi was made of stiffer material to keep the gown in place. While most women fastened their obis in back, courtesans were required to tie theirs in front (Plate 8). Although none of these courtesan garments has survived, there can be no doubt that the women of the Yoshiwara district were among the most elegant in all Japan.

Since the Tokugawa regime dictated all aspects of the lives of its citizens, it is not surprising that the dress codes were very strict. Such laws had been established during the Nara period, but they became far more rigid in their application during the Edo period. Now the rank and class of

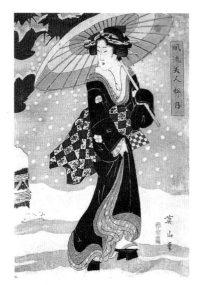

3.7 Kikukawa Eizan (1787–1867), 'Elegant Lady in Winter Snow', woodblock print, late Edo period (Ronin Gallery, New York).

the individual, the occasion on which the garment was worn, as well as the age and sex of the wearer, dictated colour, cut, and pattern. Even common people were affected. Peasants were not permitted to wear silk, and in the case of a marriage between a peasant daughter and a man permitted to wear silk, the bridegroom was requested not to wear it on their wedding day. If the couple had a child, the grandparents only could give a cotton dress to the baby (Conder, 1880). Time of year was carefully prescribed. The light summer kimono made of unlined hemp, for example, only could be worn between 15 May and 31 August, while a lined garment was worn between 1 April and 15 May and a padded one between 9 September and 31 March (Hall, 1910–11: 278–9).

Of course, the laws governing the imperial court were very strict. The reigning emperor wore ceremonial robes with large sleeves and a *hakama*, which were adorned with

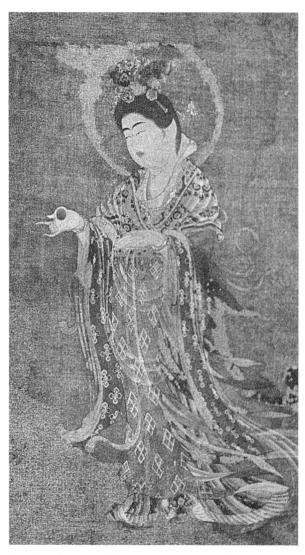

1. Kichijoten, goddess of beauty and good fortune,
AD 795 (Yakushi-ji Temple Collection, Nara).

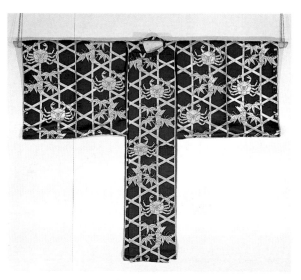

2. *Kariginu* jacket, gold brocade on light green satin-weave silk, Edo period (Tokugawa Art Museum, Nagoya).

3. Poetess Ko-Ogimi, from *Thirty-Six Immortal Poets*, a Heian-style painted scroll, Kamakura period (Yamato Bunka-kan Collection, Osaka).

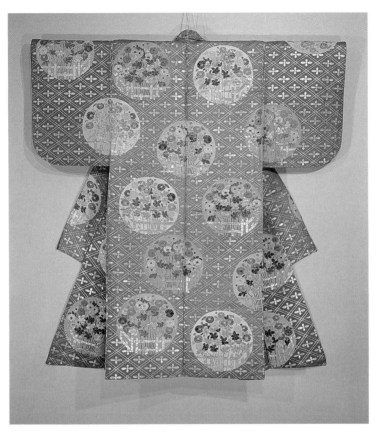

4. Noh *kara-ori* for a female role, brocade on twill-weave ground, seventeenth century (Tokugawa Art Museum, Nagoya).

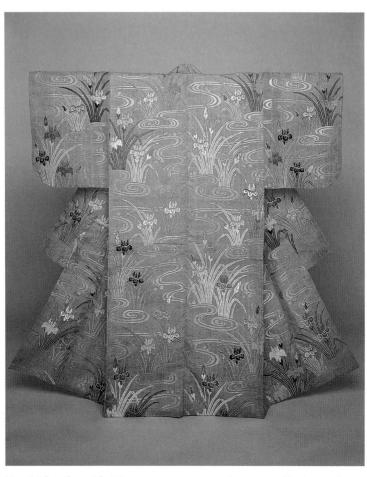

5. Noh robe with iris pattern, seventeenth century (Sugimoto Japan Arts Gallery).

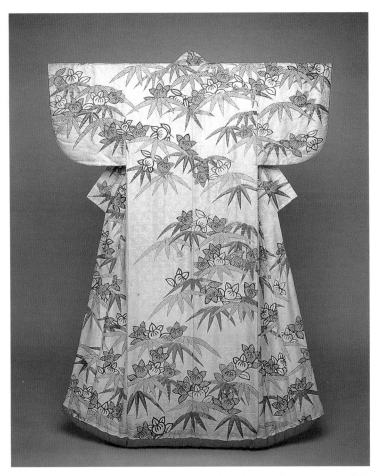

6. *Uchikake* decorated with tie-dye, embroidery, and weaving, middle Edo period (Sugimoto Japan Arts Gallery).

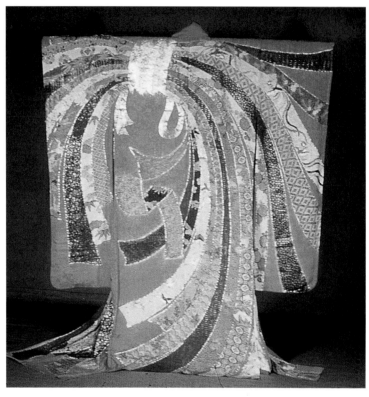

7. Long sleeved *furisode*, Yuzen dyeing, tie-dyeing, embroidery, and silver foil, middle Edo period (Yuzen Historical Society, Kyoto).

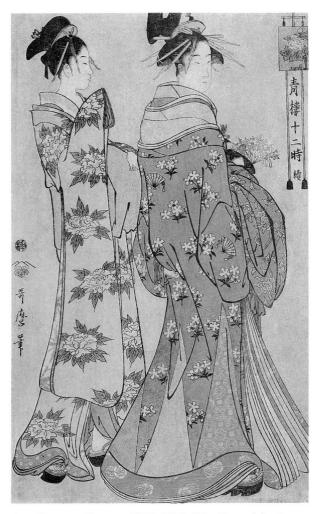

8. Kitagawa Utamaro (1753–1806), 'The Hour of the Green Monkey', woodblock print from *The Twelve Hours of the Green Houses*, c.1795 (Ronin Gallery, New York).

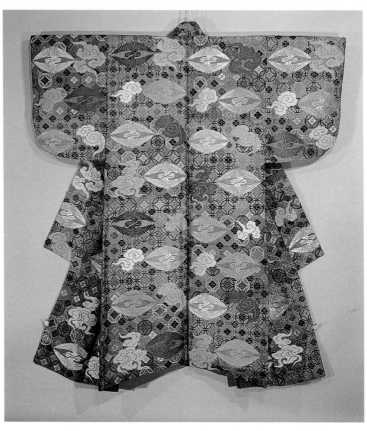

9. *Atsuita kara-ori*, inner or outer robe, early Edo period (Tokugawa Art Museum, Nagoya).

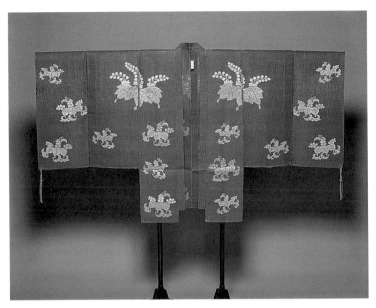

10. *Choken*, brocaded gauze, middle Edo period (Metropolitan Museum of Art, Gift of Mrs Howard Mansfield, 1950. 50.110.2).

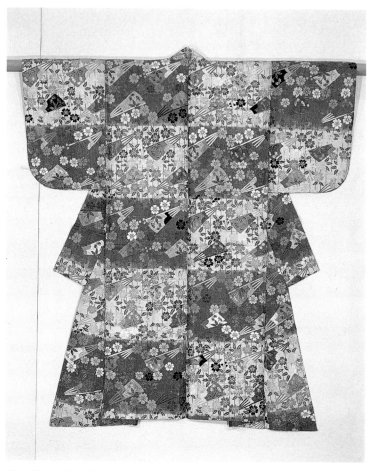

11. *Kara-ori* with fans and the branches of a weeping cherry, late Edo period (Tokugawa Art Museum, Nagoya).

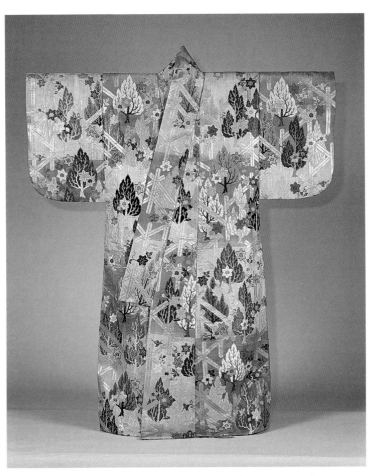

12. *Kara-ori* for female roles, brocade, early seventeenth century (Metropolitan Museum of Art, Purchase, 1932, Joseph Pulitzer Bequest. 32.30.6).

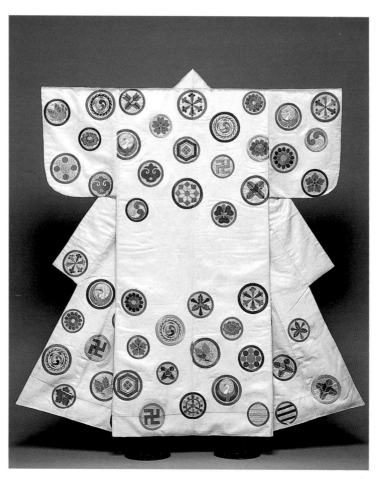

13. *Nuihaku* for female roles, white satin with brightly coloured silk embroidery on gilded ground, middle Edo period (Metropolitan Museum of Art, Bequest of Mrs H. O. Havemeyer, 1929, The H. O. Havemeyer Collection. 29.100.541).

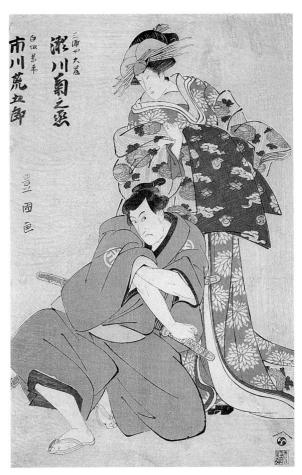

14. Toyokuni I (1769–1825), 'Kabuki actors playing a courtesan and her lover', woodblock print, c.1810 (Ronin Gallery, New York).

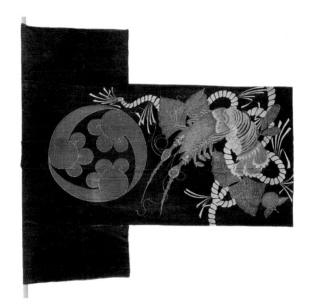

16. Ceremonial coverlet in kimono shape, resist dyes and painted designs applied free-hand on cotton, late Edo period (Metropolitan Museum of Art, Seymour Fund, 1966. 66.239.3).

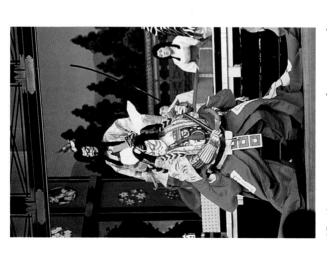

15. A contemporary performance of *Shibaraku*, Tokyo.

18. Yokohama print of Japanese lady in Western clothes, Meiji period (Author's collection, New Paltz).

17. Fireman's leather *happi* coat, Meiji period (Brooklyn Museum, Purchase, 1912).

19. Yohji Yamamoto (b. 1944). Front view of evening wear, 1995.

20. Yohji Yamamoto. Back view of same (Photos used by permission of the artist).

twelve emblematic figures. His ordinary dress was grey and yellow when it was patterned, green when it was plain. The retired emperor, on the other hand, wore silk dyed red with a mixture of wood nut, called *tsurubami*, or a robe of liquorice yellow. The ministers of state wore garments of tea-colour, with simple patterns. The nobles and lords of the court might wear dress of compound colours, such as purple and vermilion, forbidden to ordinary people. The same privilege extended to the sons and grandsons of the ministers of state and the secretaries of the emperor, who belonged to the fifth and sixth ranks. The proper colour for officials from the fourth rank and upwards was tea-colour, for those of fifth rank vermilion over an undergarment of red, for those of the sixth rank deep green, for those of the seventh rank deep blue, and for those of the lowest rank light blue.

The most elaborate prescriptions governed the clothes which the emperor wore at the ceremony marking his ascension to the throne. His costume began with an outer robe which widened toward the bottom, had a loose open collar, and very full sleeves. The robe was red damask and embroidered in gold and bright colours with representations of the heavenly constellations, dragons, sacred birds, flame-shaped emblems, and mountain peaks. The collar and sleeves were bordered with a wide band of dark blue. Below the waist, the emperor wore the red apron-like skirt called a *mo*. It was gathered in large plaits and embroidered with two wreaths, an axe head, and a fret pattern. Beneath this he wore the usual silk *hakama* and underclothes. The emperor also had a formal headdress somewhat resembling a crown, since it was embellished with gold and precious stones. Last came a handsome girdle with its front portion hanging down, decorated with Chinese paintings (Conder, 1880: 353–4).

4

Noh and *Kyogen* Robes

A HIGHLY REFINED dramatic art, Noh enjoyed the patronage of the daimyos, Japan's hereditary noblemen, and of the Tokugawa shoguns, who spared no expense in staging magnificent performances. At the same time as it is grand and dramatic, Noh is also poetic and formal, telling stories of tragedy, legend, and supernatural events, each requiring special garments for the setting and storytelling. Only male actors take part, performing on a sparsely decorated stage and accompanied by a chorus and the music of three drums and a flute. The beauty of the robes, the subtle elegance of the archaic language, the slow and deliberate movement of the actors, and the austerity of the stage settings create a truly artistic effect.

Noh was founded in the late fourteenth century by Seami (1369–1434), a gifted actor and theatrical producer patronized by the third Ashikaga shogun Yoshimitsu (r.1368–94). The oldest surviving Noh garments date from the fifteenth century, the reign of the sixth shogun, Yoshimasa (r.1440–73), and it has been suggested that the shogun himself actually wore them. Subdued in their elegance, they are quite different from current Noh costumes. The most famous example is a short dark green jacket, referred to as a *happi*, which is owned by the Kanze family of Noh actors. It is decorated with an all-over pattern of paired dragonflies, executed in gold thread. The result is delicate and refined, typical of the styles of the Muromachi period.

Many garments survive from later centuries, treasured and collected, as were the beautiful masks used with them, by the families of Noh actors and Noh devotees. Since Noh

28

is a traditional art in which the same plays are performed over and over again, it is not surprising that the robes, as well, tend to remain the same century to century. Replacements often have been merely copies of the garment replaced. As a rule, only the finest materials were used: brocades, heavily embroidered silks, and cloth imprinted with gold and silver leaf. Always keeping within the confines of the tradition, the most skilled weavers of the Nishijin district created ever new and varied decorations.

The costume worn by an actor depends entirely upon the role played, with certain standard characters associated with certain types of garments. Thus, a given costume suggests a character type—a beautiful woman, a handsome young man, a priest, or a demon—rather than the setting of a particular drama. Within this general framework, the designer has had great leeway.

An important aspect of Noh costume is colour. White is considered the most dignified and therefore appears on noble characters, while brown is considered the least dignified and so is associated with servants and country people. Red is worn by young girls but never by old women, who are dressed in darker, more subdued colours. Light blue is thought to reflect a quick temperament, whereas dark blue indicates a vigorous, extroverted person. Light green generally is reserved for menials. Often, of course, combinations of colours are used in one robe, or different coloured robes are superimposed one upon another.

The main costumes worn by actors playing female roles are the *kara-ori*, *nuihaku*, *surihaku*, *choken*, and *maiginu*, while the chief garments worn for male roles are the *atsuita*, *kariginu*, *happi*, and *noshi*. The styles generally come from noble garments of earlier times, especially the Heian and Muromachi periods, although modified to suit the needs of Noh drama and contemporary taste. In a few cases, a

robe can be worn by an actor playing a character of either sex. The *nuihaku*, normally employed by actors impersonating women, also can be used for courtiers, youths, or children. The *kara-ori*, as well, although primarily a female garment, could be worn by an actor playing the part of a very elegant young man.

The decorative patterns employed by the textile artists working for the Noh theatre show at times a breathtaking boldness, and at others an extraordinary delicacy and refinement. The more bold designs, especially if they involve the depiction of lions, clouds, and lightning, are usually associated with strong men, while delicate floral and grass designs appear on the clothes of female characters.

Since Noh costumes adhere to traditional types and patterns, dating of an individual garment is difficult. However, here again it is generally thought that the robes dating from the Momoyama and early Edo periods are the finest, those of the middle Edo still very good, while those of the nineteenth century, especially from the Meiji period, show a marked decline in quality. Although Noh garments are still being made today, it is generally conceded that they do not meet the high standards of former times.

The *kara-ori* is the most spectacular of all Noh costumes, for it indicates a person of noble lineage and exquisite taste. It is made of very stiff brocade, using colourful decorative patterns of great beauty (Figure 4.1). The designs are woven with colourful wefts resembling embroidery, often with gold and silver thread. The *kara-ori* is worn over a regular kimono, also lovely, although in a more subdued and simple way.

The most important costume worn by actors playing male roles is the *atsuita*, made of stiff brocades and decorated with bold, colourful designs, tied-down pattern threads, and a touch of gold. Used by actors playing many differ-

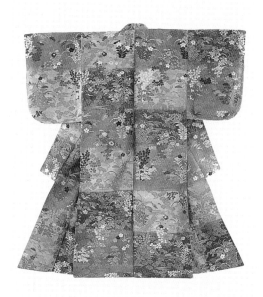

4.1 *Kara-ori*, silk twill on stiff brocade, middle Edo period (Eisei Bunku Foundation, Tokyo; photo courtesy the Japan Society, Inc., New York).

ent male roles, especially noblemen and supernatural beings, the garment conveys strength rather than delicate refinement. A particularly impressive example shows a pattern of stylized cranes, water, and rocks (Plate 9).

The next most important costumes are the *kariginu* for men and the *nuihaku* and *surihaku* for women. The former was originally an informal hunting dress worn by Heian noblemen, but in Noh drama it is worn by aristocratic gentlemen, Shinto priests, and divine beings. A rather narrow outer robe with broad sleeves, which may be lined or unlined, it usually is ornamented with brightly coloured decorative patterns. The lined version is most often worn by actors representing deities and men of high rank, while the unlined *kariginu* is worn by actors portraying Shinto priests.

31

The *nuihaku* and the *surihaku* are undergarments for actors playing female roles, and a *kara-ori* is worn over them. They are particularly splendid, for the term *haku* refers to the imprint of thin gold leaf which decorates these robes. In the *nuihaku*, the gold leaf is combined with embroidery; while in the *surihaku*, the effect depends primarily on gold and silver leaf. Garments of these types are very rare, and often the gold and silver have worn off.

Other garments designed primarily for female roles are the *choken* (Plate 10), translated literally as 'long silk', and the *maiginu*. Both are short jackets with broad sleeves, intended to be worn over the kimono. The *choken* sometimes is worn by actors playing male roles, whereas the *maiginu* is reserved for female dancers, who use the long sleeves to underline the movements of their dance.

The most common jacket used for male roles is the *happi*, a knee-length garment with long hanging sleeves which are folded back. It is associated with high-ranking warriors and the heroes of military exploits. Normally it is worn with a *hakama*, decorated with bright patterns woven in gold thread. A last garment, which can be traced back to the Heian and Kamakura periods, is the *noshi*. It is worn by actors playing such parts as emperors and imperial princes. However, since these characters do not occur frequently in the dramas, this garment has not often been seen.

For particularly dramatic effects, several of these garments are worn one over another. At the climactic moment, when the true identity of the character is to be revealed, he will slip off the outer robe to display a different one underneath. In this way, Noh garments not only contribute to the visual impact of the drama, but they play a significant role in the unfolding of the plot. In a Noh drama called *Dojoji*, for example, a beautiful dancing girl removes her outer garment and young lady mask to reveal the *han-*

nya mask of a female demon and a white robe covered with the golden scales of a serpent.

Of the many splendid Noh robes preserved in Japan, those in the Tokyo National Museum are probably the finest. Among the most famous is an *atsuita* intended for male roles. Its decoration is of the *katami-gawari* kind, with each half of the garment differing from the other in colour and design. On one side is a poem taken from a Heian-period anthology written in gold on red ground. On the other, the poem is executed in red on gold ground. The words actually are woven into the cloth, but the execution shows such skill that they appear to be painted onto the fabric.

Among several fine private collections, one of the best belongs to the Tokugawa Art Museum, Nagoya, which is particularly rich in Noh robes of the Edo period. Especially noteworthy are the collection's numerous *kara-ori* robes with floral designs, such as one for a child actor dating from the eighteenth century and displaying a chrysanthemum and cloud pattern (Figure 4.2). Another, dating from the nineteenth century, shows fans and the branches of a weeping cherry (Plate 11). An excellent garment intended for male roles is an *atsuita* with a small plaid pattern in brocade on a ground of white twill silk (Figure 4.3). This was the inner robe of the central character, who later revealed himself as a god. Compared to outer garments, this robe is very subdued, but it is elegant and complex in its technique.

In the United States, the most outstanding collection of Noh costumes is in the Metropolitan Museum of Art in New York. Several fine robes owned by the museum have been mentioned earlier, but two more might be illustrated. One is a seventeenth-century *kara-ori* brocade robe used for female roles, with decoration consisting of cryptome-

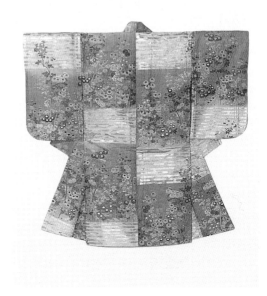

4.2 *Kara-ori* for a child actor, red and white rung-dyed twill-weave on silk ground, middle Edo period (Tokugawa Art Museum, Nagoya; photo courtesy the Japan Society, Inc., New York).

nia trees, paulownia leaves, and fences in gold on a light brown and russet ground (Plate 12). The other is a *nuihaku* for female roles, in which the decorative design has various *mon* or crests of noble families (Plate 13). The *mon* are embroidered in bright-coloured silk on gilded ground over white satin. It is worn as an undergarment beneath a brocade in such plays as *Dojoji*.

Closely related to Noh dramas are the comic interludes known as *kyogen*. Since they deal with common people, often in a humorous manner, the *kyogen* have most often used simple, rustic garments. Only in recent times, under the influence of the folk art movement, has their beauty been appreciated. Interest in these garments led to the publication of a sumptuous book on *kyogen* dress by Ken Kirihata (Kirihata, 1980).

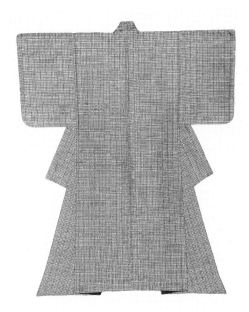

4.3 *Atsuita* inner robe, gold, brown, and green plaid brocade on white twill-weave silk ground, late Edo period (Tokugawa Art Museum, Nagoya; photo courtesy the Japan Society, Inc., New York).

The two main types of costumes employed on the *kyogen* stage are the *suo*, a short jacket with long sleeves, and the *kataginu*, a sleeveless garment. Both are made of hemp rather than brocade or silk, and they are usually decorated by the paste-resist dye process. The designs are strong and simple, in keeping with the plebeian character of the roles. The earliest surviving *kyogen* robe (on loan from the Amano shrine, Koyasan, to the Tokyo National Museum), believed to be from the sixteenth century, shows a design of umbrellas in blue on a brown background of hemp. However, most of the garments date from the nineteenth or twentieth century, and it was only in the modern period that they began to be collected seriously.

Our knowledge of earlier *kyogen* costumes largely comes from paintings and literary descriptions. It appears that the

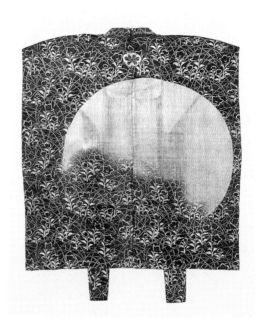

4.4 *Kataginu,* for use in kyogen plays, blue-green and white stencil-dyed hemp, late Edo period (Private collection, Japan).

kyogen actors wore the *kataginu* together with the *hakama,* a combination referred to as *kamishimo.* The motifs employed are usually from nature and are treated in a bold manner with simple dye techniques. An excellent example shows a huge harvest moon dramatically rising over a field of bellflowers and dense pampa grasses, stencil-dyed on hemp (Figure 4.4). Other *kyogen* robes show varieties of flowers, grasses, birds, animals, and insects. Particularly popular were the flowers of the four seasons, with dandelions and grape blossoms signifying spring, hydrangeas and pinks representing summer, chrysanthemums, balloon flowers, and bush clover symbolizing autumn, and evergreen pines and bamboo standing for winter. Unique to these garments is the use of ordinary vegetables such as turnips and radishes, and the appearance of more modest creatures, such as praying mantises, as decorative elements.

5

Kabuki Robes

IN CONTRAST to Noh drama, a highly refined and aristocratic art supported by the court and the nobility, kabuki is a plebeian and popular dramatic form. Kabuki, literally 'the art of singing and dancing', originated during the early Edo period, and the first complete play was performed in 1664. The performances combine stylized acting with lyrical singing, dancing, and elaborate stage design. The final repertoire of the kabuki theatre consists of some 350 plays, including dramas, comedies, and dances. Its golden age came during the Genroku period (1673–1735), when this type of theatre enjoyed wide popularity among the common people of Edo. Although kabuki costumes never were as remarkable, aesthetically or technically, as those of Noh, they were colourful, often extravagant, and contributed greatly to the appeal of the plays.

In sharp contrast to the case of Noh drama, where the garments have been passed down for generations, no early kabuki costumes have survived, since they were discarded when they had worn out. We must depend on literary accounts and pictorial evidence to reconstruct the kabuki costumes of the Edo period. The oldest documented information comes from records of the robes worn by the leading actor of the Meiji era, Ichikawa Danjuro IX (1838–1903), honoured as ninth in a line of great actors upon demonstration of his extraordinary talent. Today, these descriptions are in the Theatre Museum of Waseda University, Tokyo. The oldest surviving costumes belonged to the actor Bando Mitsuemon (1788–1846) and are now in the Tokyo National Museum.

The best pictorial source for kabuki robes of the Edo period is Ukiyo-e prints, which portray the leading actors of the day in their characteristic roles. It is believed that they represent the typical garments quite accurately. The two groups of Ukiyo-e artists who specialized in these actor prints were members of the Torii school, active from the late seventeenth century through the eighteenth century, and Katsukawa Shunsho and his many followers, among whom Toyokuni I (1769–1825) was one of the most illustrious. A good example of a Toyokuni print depicts Segawa Kikunojo (1802–32) and Ichikawa Aragoro (1759–1813) playing a courtesan and her lover in a drama from around 1810 (Plate 14). The splendour of the female costume, with the obi tied in front to show that the character is a prostitute, is characteristic of the costumes worn by actors impersonating women.

The garments worn by kabuki actors strongly influenced the fashions of their day. Geishas and courtesans, as well as ordinary women, flocked to the theatre to study the latest styles. It is said that Mizuki Tatsunosuke (1673–1745) started the rage for the pattern of multicoloured stripes called *dandara-zome*, that the Osaka actor Sanogawa Ichimatsu (1722–62) made popular the chessboard-patterned cloth thereafter called *ichimatsu* (Figure 5.1), and that the Edo actors Nakamura Karoku (1779–1859) and Nakamura Senya (dates unknown) were the first to use large tie-dyed designs, which were called *Koroku-zome* and *Senya-zome* after their given names.

Ruth Shaver, in her excellent book about kabuki costumes, characterizes them in the following way:

The Japanese costumers, known as the *isho-ya*, combined a notable array of colour, at times almost discordant, to produce dazzling costumes of incredible beauty and unexpected vibrancy.

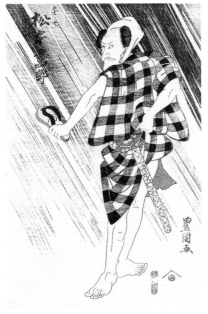

5.1 Kabuki actor Matsumoto Koshiro wearing the chess-board-patterned cloth called *ichimatsu*, in a print by Toyokuni I (1769–1825), c.1810 (Ronin Gallery, New York).

Some costumes are startling in their rich hues or in patterns sweeping from neck to heel, while others are beguiling in their unadorned simplicity. The *isho-ya* clothes his comics in costumes that are amazingly original bits of bold comedy in themselves, but it is for the dance drama known as *shosa goto* that today's costumer is most articulate. With the masterliness of a Kandinsky, he combines delicately and sensitively as many as thirteen distinctly different colours for a single costume—for example in the opening scene the kimono worn by Onoe Baiko VII as the famous Wisteria Maiden in the *Fuji Musume*: a delightful inspiration of soft pink, light green, canary yellow, orange, purple, leaf green, white, gold, candy-stick red, silver, delicate lavender, shocking pink and black (Shaver, 1966: 113).

The sex, age, and social position of the character dictated the type of kimono worn. The types themselves were

mandated by the same strict regulations which governed Edo society. An actor impersonating a young girl could only wear a brightly coloured red or pink garment with long sleeves, for example, while an older woman was identified by more subdued colours such as brown and grey. The costume worn by an actor in the role of a nobleman was very different from that worn by someone in the role of a commoner. The gaudy dress worn by an actor playing a courtesan of the Yoshiwara district would be very unlike that worn by an elegant, refined princess. For kabuki devotees, all these clues of costume were clearly recognizable and helped them to understand the drama as it unfolded.

The costumes worn on the kabuki stage still preserve the styles and designs first seen during the Edo period. With no regard for historical accuracy, characters are sometimes dressed in purely imaginary garb, while others from the Nara or Heian periods are dressed in Edo fashions. The only exceptions are the twelve-layer garments worn by the actors who play princesses of the Heian court. Although none of these are the equal of the finest of the Noh robes, they are often beautiful in colour and design. Weaving, embroidery, and dyeing combine to create dramatic results.

The established actors usually paid for their own costumes, but the theatrical companies often provided dress for minor players who could not afford to clothe themselves. These garments were kept in a warehouse called the *kura-isho*. Among the standard costumes which might be found there were formal samurai dress, known as *kamishimo*, the *kesa* for priests, *hitatare* for actors playing daimyos or the shogun, a red undergarment called *juban*, raincoats referred to as *kappa*, *hakama* trousers, *kariginu*, the wide-sleeved kimono worn by noblemen, animal costumes known as *keshin-mono*, *momohike*, tight, long navy blue trousers, *suo*, a set of male clothing consisting of the coat called

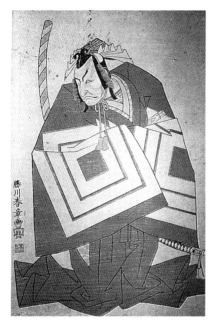

5.2 Ukiyo-e print by Katsugawa Shunsho (1726–92) showing Ichigawa Danjuro IV (1711–78) in a performance of *Shibaraku* (Author's collection, New Paltz).

uwagi and long trailing trousers or short pleated trousers, as well as several types of headdresses and mittens.

There are many costumes which the regular kabuki-goer and the collector of actor prints will recognize at once. Perhaps the best known are those worn by actors in the lead role in one of the most popular of all Kabuki plays, the drama *Shibaraku* (Wait a minute!). The hero Banzaemon stops the villain Daizai-no-jo with the cry of *Shibaraku!* The scene is always played in the bombastic *aragato* style with the actor dressed in splendid garments. It was first performed by the celebrated actor Ichigawa Danjuro I (1660–1704) in the opening years of the eighteenth century, and it continues to be staged in the same manner with the same costume designs to the present day. A Ukiyo-e print by Katsugawa Shunsho depicts the famous actor

41

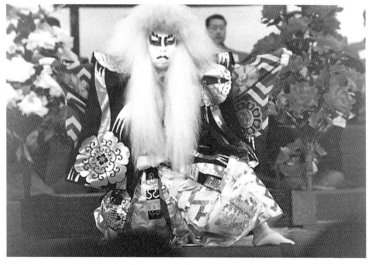

5.3 A contemporary performance of *Kagamijishi*, Tokyo.

Ichigawa Danjuro IV (1711–78) in the Shibaraku role (Figure 5.2). The actor wears a reddish-brown garment, decorated with large square grain measures, known as *mimasu*, on his sleeves. A photograph of a contemporary performance of *Shibaraku* portrays the hero with his outer garment let down, revealing a gorgeous undergarment in red, green, and white (Plate 15).

One of the most popular of the female roles is the Wisteria Maiden, in the dance drama *Fuji Musume*. She wears a costume decorated with wisteria blossoms. Another celebrated female role is that of the beautiful girl who turns into a demon in the dance drama *The Maid of Dojoji Temple*. In the first part of the play, the heroine Kiyohime appears as a pure and simple girl, dressed in a long-sleeved kimono of Edo style, and she dances with a towel and a hat adorned with flowers. In the second part, however, she is trans-

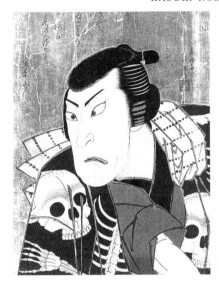

5.4 Shunkosai Hokuei (fl. 1829–37), 'Kabuki actor', c.1830 (Private collection, New York).

formed by love and jealousy for the handsome monk Anchin who has rebuffed her. She wears a white inner garment called *uchiginu* with a triangular snake pattern and a long divided red skirt.

Of the more fantastic roles, the best known is probably that of the hero in the dance drama *Kagamijishi*. He appears in a magnificent pair of loose *hakama* trousers, a *happi* of brilliant gold, and a splendid white wig indicating that he is a lion, the king of the beasts (Figure 5.3). In a similar way, all kinds of supernatural creatures, gods, and demons are identified by the costumes they wear and the make-up they employ (Figure 5.4). Kabuki drama is a magnificent spectacle with the text, performance, and colourful garments all contributing to the artistic whole.

6

Priestly Robes

THE PRIESTS of Japan, both those serving the various Buddhist sects and those of the native Shinto religion, wear special dress when performing sacred rituals. The origin of the Buddhist garments, like that of most other objects in Japan connected with Buddhism, may be traced to Korea and ultimately to China, for the fabrics employed during the early years of Japanese Buddhism came from the mainland. As early as the Nara period, however, the priestly robes, altar cloths, and *ohi*, or stoles, began to be made by native weavers. Early examples of such textiles are preserved in the Shoso-in, the famous storehouse of ancient art on the grounds of Todai-ji in Nara.

No fewer than nine Buddhist priests' robes dedicated to the Todai-ji by the widow of Emperor Shomu (r.724–49) remain in the Shoso-in. The garments, called *kesa*, consist of square patches of silk or brocade usually measuring three feet by four feet. Originally such *kesa* were made from cast-off scraps of cloth gathered in the streets, cleaned, and patched together, thereby symbolizing the humility of the lord Buddha. Later on, the fabric often was cut into small pieces and sewed together in a definite pattern, and in even later times, an illusion of tattered cloth was suggested by weaving such a pattern into the fabric itself.

The Shoso-in *kesa* look very fragile, but that may well have been an intentional effect, to emphasize the idea that they were literally patched together from old bits of cloth. They display a cloud-like pattern of mottled shades of grey and brown, a colour known as 'tree bark' in Japan, and all but one are a type of cloth called *shino*, which means 'patch and stitch design'.

While most of these early silk *kesa* are of solid silk weave, one in the collection uses the tapestry weave called *tzuzui-ori*. The design is a cloud-like patchwork of subtle beauty, indicating how, already during the Nara period, the finest products of Japanese looms and the best imported textiles were employed for priests' garments. Buddhist paintings of the Heian and Kamakura periods also show the patriarchs of the various Buddhist sects and the Bodhisattvas dressed in the most gorgeous garments, decorated in gold and silver with beautiful textile patterns. Fragments of such robes often were re-used for scroll mounts or as bags for precious tea utensils, allowing them to be preserved to the present day.

Most of the fine priestly robes which survive come from the Momoyama and Edo periods. In more recent times, as Buddhism has declined and the temples have become impoverished, the quality of the garments has declined. Aniline dyes and cheap gold thread, which tarnishes easily, have replaced traditional materials. In addition, temples often sell or exchange their old robes, seeking brighter and newer-looking ones. Although a tragic loss for the temples themselves, this development has brought many examples of old *kesa* into the collections of museums and private buyers, not only in Japan but also in the United States. The Metropolitan Museum of Art, New York, the Art Institute of Chicago, and the Yale University Art Gallery in New Haven have outstanding collections.

Many *kesa* are made of cloth originally intended for secular purposes. It was the custom of families to give robes which had been worn by the dead to the temples after burial. Devout women also gave precious garments to their place of worship, and many cast-off Noh and court robes were dedicated to temples and shrines. The result was that the robes and hangings of Buddhist sanctuaries often used

6.1 Buddhist abbott's *kesa*, rose-coloured silk damask, late Edo period (Metropolitan Museum of Art, Gift of John M. Begg, 1939. 39.85AB).

the most valuable materials despite the tradition that the patched *kesa* should reflect the poverty of the Sakyamuni Buddha. An abbot's costume of rose-coloured, flowered silk damask is one example of such splendour (Figure 6.1).

Particularly impressive are the robes made of *kinran*, which uses gold and silver foil against a dark blue, moss green, glowing red, or violet background. The *kinran* thread consists of an overlay of gold foil affixed to a fine, tough paper made from the bark of the mulberry tree. After the gold is burnished, the sheets of paper are cut into tiny strips, sometimes of hair-fine quality, to be woven in as weft thread on a loom. In some cases, silver foil might be used in place of gold.

The term *kesa* derives from the Sanskrit *kachaya* and refers to a robe worn over a plain-coloured silk kimono,

46

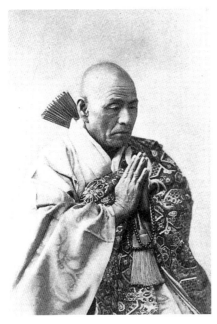

6.2 Meiji-period photograph showing a Buddhist priest wearing the *kesa* and *ohi* (Author's collection, New Paltz).

which is draped under one arm with its corners fastened on the opposite shoulder (Figure 6.2). A long narrow stole, the *ohi*, hangs over the free arm. The *kesa* has small patches of contrasting colours in the four corners. These are called the Shitenno, after the four kings who preside over the four directions. Two larger patches on one side of the *kesa* represent the two attendant Bodhisattvas, while the centre of the *kesa* stands for the Sakyamuni Buddha himself. A good example of a *kesa* and *ohi* showing these features is in the Metropolitan Museum of Art (Figure 6.3). Sacred relics, consecrated before being put into place, were often sewn into the *kesa*, indicating that the garments worn by the priests were not only beautiful pieces of textile art but were also imbued with religious significance.

Certain decorative designs connected with Buddhism

47

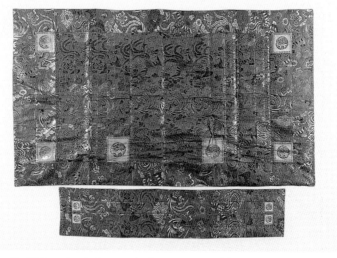

6.3 Buddhist priest's *kesa* and *ohi*, Meiji period (Metropolitan Museum of Art, By Exchange, 1954. 54.121.1ab).

appear often on the robes of Buddhist priests. Most common is the lotus, which stands for purity and is seen in all types of Buddhist art. Closely related is a pattern of stylized blossoms, seed pods, and curving stems, the Seven Flowers of Autumn. Another common motif is the *manji,* or swastika, which represents the heart of the Buddha and stands for the continuous flux and ceaseless becoming of life itself. It is often combined with the wheel, or *rimbo,* which is associated with the teaching of the Buddha. A *kesa* from the Momoyama period shows three of these motifs (Figure 6.4). Another superb *kesa,* dating from the early Edo period, uses a dragon and cloud design, executed in *shuhuji* satin and *kinran* brocade (Figure 6.5).

These elaborate robes were worn during special services and sacred ceremonies, but the priests wore far simpler garments in daily life. Standard dress was a white cassock

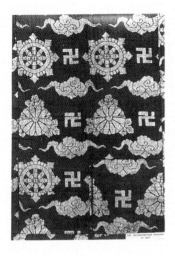 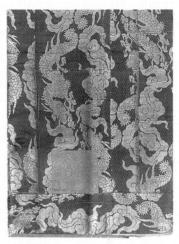

6.4 *Kesa* (detail) with a design of lotus, *manji*, and *rimbo* in brocade, Momoyama period (Metropolitan Museum of Art, Purchase, Joseph Pulitzer Bequest, 1919. 19.93.32).

6.5 *Kesa* (detail) from the Nishijin looms, Kyoto, satin and brocade, early Edo period (Metropolitan Museum of Art, Purchase, Joseph Pulitzer Bequest, 1919. 19.93.75).

with a white obi, worn over an ordinary white *juban* undergarment. Over this combination was worn a *koromo*, usually black and made of coarse cloth such as hemp or grass cloth. The *koromo* is double breasted, with a V-shaped neck fastened with several bands on the right side. The sleeves are very long, and with it is worn a pleated skirt which reaches just below the knees. When not conducting services, the priest would wear a black coat known as *juttoku* instead of the *kesa* and *koromo*. None of these garments is ever aesthetically outstanding, and so they have not been collected as the *kesa* have.

The same kind of simplicity marks the ordinary garments of the Shinto priest. When not performing sacred rites or taking part in religious ceremonies, they dress little dif-

ferently from ordinary laymen. For special occasions, however, they wear distinctive robes known as *shozuku*, based on court robes of the Heian period. A typical garment is the *hakama* with its wide divided skirt which falls to the ankles. It varies in colour, with white, light blue, and purple for dignitaries the most common. The other main items are two or more kimonos with long sleeves. Shape, colour, and use determine their names. The garments made for ordinary wear are white and are known as *saifuko*, while the *ikan* and *sokutai*, named after similar robes from the Heian period, are reserved for special occasions.

The outer robes of Shinto priests are also derived from Heian dress. The *ho*, originally a nobleman's court robe, is the most important. For the highest priests, it has an arabesque pattern on black ground. For those of the second rank, the pattern is on red ground, while the priests of the lowest rank wear a plain blue *ho*. The *hakama* has a medallion design of white wisteria flowers for the highest rank, patternless purple for the second, and plain blue for the third rank. At functions of lesser importance, priests wear solid white.

Other gowns, all of them developed from Heian-period prototypes, include the *kariginu*, which differs in colour depending upon the season, age of the wearer, and occasion. It is made of either figured twill or twill gauze. Particularly charming is the costume worn by the *miko*, the young maidens who dedicate part of their lives to the service of Shinto shrines, where they perform sacred dances and serve the worshippers. They wear red skirts called *chihaya hakama*, with a white upper garment signifying their purity. None of these Shinto garments, however, compares in design or execution with those worn by Buddhist priests.

7

Japanese Folk Textiles

FOLK ART is a unique feature of the Japanese tradition and the works themselves have assumed an important place in the history of the nation's arts. Unlike Chinese art, which generally was made for the appreciation of a small élite, Japanese art existed in folk forms which resided in and arose from the experiences of the common people. The term *mingei*, first coined by Dr Soetsu Yanagai, has become the generally accepted term to describe all the popular manifestations of artistry and craft. It consists of two characters, *min*, meaning people or folk, and *gei*, meaning skill or craft.

Dr Yanagai wrote about the folk crafts:

These utensils are characteristically simple in shape, in colour and in design. Simplicity may be thought of as being characteristic of cheap things, but it must be remembered that it is a quality that harmonizes well with beauty. That which is truly beautiful is often simple and sparing (Yanagai, 1936: 14–15).

It is the folk textiles which correspond most closely to this definition. In traditional Japan, before modern factory production was introduced from the West, every village had its own types of garments. As late as the 1950s, it was possible to discover more than 100 distinctive costumes worn by peasant women in rural areas (Hayashi, 1960).

There must have been even greater variety during the Edo period, for it was a traditional duty of the woman to make clothes for the family. In fact, the chief qualification for a bride in the northern Echigo district was her ability to weave. Her looks and manners were of only secondary

51

importance (Hikida, 1979: 542). The result was a large output of fine textiles throughout rural Japan. Very few have come down to us, however, as they were not valued highly enough to be preserved.

The material most commonly employed in folk textiles today is cotton, but before its appearance in Japan during the seventeenth century, ordinary people depended on wild and cultivated vegetable fibres. Sources for the former were paper mulberry, called *kozo*, linden, willow, wisteria, and bracken. Among the latter were hemp, ramie, jute, and linen, referred to collectively as *asa*, or wood fibres. *Asa* still is used in some rural areas, especially in northern Japan, but wood fibres are no longer employed. Silk was very expensive and, furthermore, there were regulations forbidding its use by common people. Wool was very rare, even during the Edo period. It was not until the Meiji period that ordinary people used it.

The clothes worn by villagers and the lower classes were unpretentious. The favourite colour was a deep indigo blue, supplied by local dyers. This often was combined with white or, in cloth decorated with large pictorial designs, with vegetable colours. The patterns usually were very plain, stripes and geometric shapes being the most common. From a technical point of view, as well, these textiles were simple. The materials were those at hand, and weaving, dyeing, and embroidery created the patterns.

To this day, striped patterns make up the most popular designs in folk textiles. The earliest striped fabrics were imported from Ming China during the Muromachi period, but by the Momoyama period they began to be made in Japan itself. Although none of the early striped garments worn by ordinary people have survived, commoners dressed in such clothes may be seen in genre paintings of the

Momoyama and early Edo periods. By the eighteenth century, striped cloth was immensely popular.

Especially famous for its soft, plain, yellow-striped silk textiles, called *kihachijo*, was the island of Hachijo. Places well known for their production of striped cotton fabrics were Tamba in Hyogo prefecture, Mikawa in Aichi prefecture, and the Shonai district in Yamagata prefecture. Some used vertical stripes, others horizontal, and yet others checkerboard patterns. The stripes themselves vary in width, in the breadth of the intervals, and in the colours used, creating subtle differences in the final effect.

The most active centre of production for striped folk textiles today is the village of Saji-machi, in Tamba district. Under Yanagai's sponsorship, a revival of folk textile arts took place in the postwar period. In Saji-machi, the weft stripe is made of white waste silk and is interwoven with heavy cotton, usually dyed in warm tan or varying shades of indigo. In contrast to earlier times, however, when such cloth was made by and for the common people, modern Tamba cloth is very expensive. It is intended for the sophisticated urban *mingei* enthusiast.

Next to striped patterns, *kasuri* was the most popular design in Japanese folk textiles. The technique originally came from Indonesia, where the resulting fabric is known as *ikat*, or from China by way of Okinawa. The earliest Japanese *kasuri* possibly was made in Satsuma, in southern Kyushu, during the 1740s. By the beginning of the nineteenth century, cotton *kasuri* was being made all over Japan. The most common design used indigo blue and white, while the simplest patterns featured star and cross shapes. Irregularities in the edges of the shapes create a varied visual effect. *Kasuri* with pictorial designs, called *e-gasuri*, or picture *kasuri*, were particularly popular in Kurume, on

Kyushu, and in Ehime, on Shikoku, where they were usually made by farmers' wives. Motifs included buildings, wells, tigers, birds, pines, bamboos, and other familiar objects.

Like striped cloth, *kasuri* was at its best during the nineteenth century and declined during the modern age. In the postwar period, however, *mingei* enthusiasts have celebrated the unique beauty of the older fabrics and, as a result, *kasuri* production has been revived. In Kurume in Kyushu, fine cotton *e-gasuri* is being made, and in Niigata prefecture, hemp is used for *asa-gasuri* with small hand-tied motifs. *Kasuri* still is produced in two of the three areas which the Japanese government designated in 1975 as regions for traditional textile handicrafts.

In addition to the *kasuri* technique, in which yarn was tied sectionally for resist dyeing, the *mingei* dyers have also used starch-resist dyeing. Called *nori-zome*, the technique uses rice starch or wax to cover the parts of the cloth that should not be dyed. The designs may be applied freehand, a method referred to as *tsutsugaki*, with the help of a tube or cone from which the paste is squeezed out. A splendid example of a cloth dyed in this way is in the Metropolitan Museum of Art (Plate 16).

Another process, called *katazome*, employs stencils to create the design. In years past, there were stencil dyers in every small town, using thousands of different designs to fulfil the enormous demand for this style of cloth. One of many collections of these patterns is Andrew Tuer's handsome *Japanese Stencil Designs*, first published in 1892 (Tuer, 1967). The stencils themselves largely came from Shiroku, a small town near the Ise shrine in Mie prefecture. Originally made of wood, during later times they were made of thick paper reinforced by hair. The stencil cutters were highly professional craftsmen who produced a wide

range of designs, from small repeating patterns to large pictures. One of the most popular types of stencilled garment is the light cotton summer kimono, the *yukata*. Originally a garment for after the bath, today the *yukata* is acceptable for informal everyday wear in the house and garden.

The third major category of Japanese folk textiles consists of those decorated with embroidery. This type of fabric, called *sashiko*, uses a running stitch in straight lines or decorative patterns to reinforce the material. Usually the cloth is indigo hemp or cotton, and often more than one layer is used or it is quilted to provide greater warmth. Originally, this embroidery was purely utilitarian, but the decorative aspect became increasingly important, and today *sashiko* stitching is used solely for its ornamental value. About fifty different motifs exist, varying from completely formal abstract patterns to representational designs.

The best of the stitched peasant garments come from the northernmost part of Honshu, especially Aomori prefecture. In the Tsugaru district, there is *kogin*, which consists of indigo-dyed hemp embroidered with white cotton thread, while the Nambu district of eastern Aomori produces a type of jacket called *hishizishi*. *Hishizishi* is also made of *asa*, embroidered in a blue and white diamond pattern. An experienced worker—women were skilled by the time they were seventeen or eighteen—could produce such a garment in about five days. Again, the best *kogin* and *hishizishi* fabrics were made during the nineteenth century.

Traditionally, Japanese peasants wore a short coat, baggy pants called *mompe*, straw sandals, and simple gaiters. This outfit still may be seen in rural areas, although Western-style dress has become common. Workmen still wear the *happi* coat, an unlined garment of durable, dark blue cotton, with the name of the shop or trade indicated in bold white characters on the front and back. Common people

often wear kimonos of cotton, unlined during the summer months and lined or cotton-quilted during the winter.

One profession with distinctive clothing was firemen, for they wore a unique leather coat covered with boldly stencilled designs (Plate 17). The coat, still worn as formal dress, was made of deerskin tinted brown by smoking and decorated with family crests, trade marks, and stylized lettering. The stencil technique came from India, hence its name, *inden*. It is said that the use of leather first occurred after the great fire of 1657, and soon spread to artisans and the foremen of work crews as well. Originally restricted to Edo, the practice later gained favour in other areas. Firemen also dressed in thick quilted cotton garments to protect them against the fire and water. The lining of such coats often was painted in the manner of Ukiyo-e prints.

Fishermen celebrate a large catch with special rituals, in which the boat crews go to the local shrine to thank the Shinto gods for their good fortune. The kimonos worn for these occasions, distributed by the ship owners, are called *man iwai*, which means celebration of good luck. Bold designs executed in the *tsutsugaki* technique, where a comb is used to make the pattern for dyeing, decorate them. Favourite motifs include fish, shellfish, symbols of good luck, or such symbols of longevity as tortoises, cranes, lobsters, and pines. The finest of these kimonos are among the masterpieces of Japanese folk art.

Another unique kimono, known as *yogi*, was used as bedding during the Heian period. It had an extra width in the centre of the back and was heavily padded with cotton. These *yogi* were spread over the back of the sleeper with a round collar fitting under the chin and over the shoulders. A fine example is in the Metropolitan Museum of Art.

The most distinctive of all peasant garments is the traditional *katasugi*, worn by women over the head and shoulders to hide their faces during weddings and funerals. They were particularly popular in the Shonai district of Yamagata prefecture. Large decorations, usually floral or geometric designs dyed in blue and green, were stencilled onto the surface of the cloth, and the *tsutsugaki* method was used in those areas to be pulled over the head.

8

Dress of the Meiji and Modern Periods

CLOTHING DESIGN and textile manufacture changed profoundly with the opening of Japan to the West and the beginning of the Meiji period in 1868. In place of small-scale workshops employing a few people and using simple looms and natural dyes, large-scale factory production and chemical dyes became the norm. At the same time, Western fashions began to be popular among the upper classes and were even mandated for certain occupations. In 1857, students of the Dutch language in Saga prefecture (then Hizen province) were first permitted to dress in foreign-style clothes. In 1861, sailors were commanded to dress in Western uniforms, and army officers as well as common soldiers followed them in the next year.

In 1868, the sewing machine was introduced, facilitating the making of Western-style garments (Figure 8.1). In the previous year, Viscount Eichi Shibuzawa had appeared in European dress, and in 1870, the Emperor himself was seen wearing a mantel. Finally, in 1871 ordinary people received permission to wear these garments and as many as could afford it did. Since they were expensive, however, Western clothes often were worn with Japanese garments. It was not uncommon to see a man wearing leather shoes, a derby hat, and a traditional kimono. The centre of this elegance was the Rokumeikan ballroom, where European balls were held for the Japanese aristocracy between 1883 and 1889. This Meiji fashion is best recorded in Yokohama prints, such as the woodcut from about 1890 (Plate 18). An elegant Japanese lady wears the latest European attire, accompanied by a servant in Western livery.

The great mass of people, however, continued to wear

貴女裁縫之圖

8.1 Adachi Ginko (fl. 1874–97), 'Women of Fashion' (detail), 1887
(William Sturgis Bigelow Collection, Museum of Fine Arts, Boston).

traditional Japanese dress. Even in the upper classes, a reaction against the initial enthusiasms set in after 1889. In fact, a reaffirmation of native dress took place during the later Meiji period. The English scholar Basil Hall Chamberlain reported at the turn of the century that upper-class men generally still wore the kimono, or in winter two padded gowns known as *shitagi* and *awagi*, with a narrow obi, a loincloth, and the shirt of silk or cotton called *juban* underneath. An additional undergarment might be added for colder weather. On formal occasions, the *hakama* and a silk *haori*, a three-quarter length wrap decorated with the family crest of the wearer, would be worn (Chamberlain, 1904: 122). The other sectors of the society, especially the rural population, were both more conservative and less wealthy. They continued to dress in the old ways.

8.2 'A Lotus Garden',
Meiji-period photograph
(Author's collection, New
Paltz).

Women, as well, tended to be more conservative than did men. Chamberlain reported that women generally wore two little aprons around their thighs, a shirt, and then a kimono, kept in place by a thin belt known as *shita-jime*. Over this, a broad obi was held up by a sort of pannier, called *obi-ogi*, which in turn was kept in place by a handsome tie referred to as *obidome*. All of these pieces were made of splendid materials and in exquisite taste. A Meiji photograph of an older woman dressed in dark colours and a young girl dressed in brighter colours in a lotus garden illustrates the period style (Figure 8.2).

The tendency to wear Western clothes grew more marked after the First World War. Now women also wore Western-style clothes, as they joined the workforce and found the kimono inconvenient for modern urban living. Progressive and modern professional women saw Western dress as an expression of their new freedom, while women from more traditional families continued to value their beautiful kimonos

8.3 Takehisa Yumeji (1884–1943), 'Green liquor', 1940 (Author's collection, New Paltz).

as highly treasured family heirlooms. Just as in other aspects of their lives, Japanese had two distinct sides: one Western and one Japanese. After wearing Western-style clothes in factories and offices, they changed into a kimono or *yukata* once they returned to the informal atmosphere of their homes (Figure 8.3).

The final break with tradition came during the Second World War, when the shortage of cloth and a general austerity made the kimono unsuitable for wartime living. After the defeat and occupation of the country, Western-style dress became the accepted norm for all classes of society and for both sexes. Today, Japanese women reserve their kimonos for special occasions such as festivals and weddings, while men wear the formal kimono or *hakama* only rarely.

The light summer cotton *yukata* is the only commonly worn traditional garment. It has become a favorite for both sexes for hot-springs resorts, summer festivals, and for home

8.4 Modern photograph showing a woman and child dressed in *yukatas* (Author's collection, New Paltz).

living. A typical scene shows a woman and child dressed in the dyed cotton *yukata* in their yard (Figure 8.4). In recent decades, there also has been a move toward a simpler and more practical kimono, termed the New Kimono, which combines traditional aesthetic effects with some of the conveniences of Western clothes.

The only place where truly traditional Japanese garments are still worn is the imperial court. With their great love for preserving ancient traditions, the Japanese continue to stage Noh dramas written in the language of the Muromachi period, perform the *gagaku* and *bugaku* music and dance brought from Korea in the seventh century, and restore old temples and shrines to their original form. The court uses Heian-style garments for certain ceremonies, such as the coronation and ascension to the throne of the emperor, imperial weddings, and coming-of-age festivals for members of the imperial family.

For such events, men wear the *sokutai*, with colours and patterns depending on the wearer's rank. A loose outer robe with deep square sleeves is worn over several other garments. Under these is worn the *hakama* and, trailing behind, is seen part of one of the inner robes. The empress, the princes of blood, and the leading ladies-in-waiting also wear traditional Heian gowns. Their formal costume is called *karaginu-tsutsuginumo*, popularly known as *juni-hitoe*, the twelve-layer gown. There also is a modified version of this garment referred to as *ko-uchigi*.

In recent years, a growing sense of nationalism and a greater pride in Japanese cultural heritage have revived interest in the kimono. Schools teaching how to sew and wear it have sprung up all over Japan. Norio Yamanaka, chairman of the All Japan Kimono Consultant Association, eloquently described the experience of putting on a kimono and tying the obi properly as 'a physical and spiritual transformation' (Yamanaka, 1982). According to Yamanaka, there are no fewer than two hundred rules regarding the kimono and up to five hundred ways of tying the obi. Yamanaka believes that mastering these arts is a sign of good breeding and manners.

The kimonos worn today on special occasions follow a standard design. A ceremonial kimono for men is made of black silk and is decorated with the family crest. Over it may be worn a *haori* with a *hakama* beneath. For less formal wear, the kimono and *haori* may be made of wool during the winter and light cotton or hemp in the summer. Such garments are worn only at weddings, funerals, and other important ceremonies. On all other occasions, men generally wear a business suit or white shirt with dark trousers.

Women tend to wear the kimono more frequently, and every young woman of a good family owns at least one or

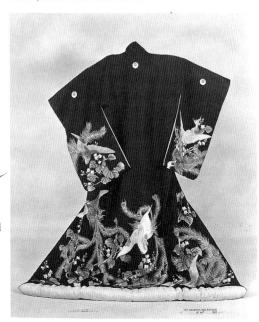

8.5 Wedding kimono, embroidered silk, late nineteenth century (Metropolitan Museum of Art, Gift of Mrs John D. Rockefeller, Jr., 1937. 37.92.10).

two. These alone may represent a considerable investment, since even a simple kimono costs the equivalent of hundreds of dollars, while a really fine one by a well-known designer costs considerably more. Particularly dazzling garments may be worn at weddings, when the bride wears a long outer robe known as *uchikake* over two layers of white kimonos (Figure 8.5). Japanese dress also is worn today by geishas and dancers.

The importance given to traditional crafts can be seen in that peculiarly Japanese institution, the designation of Intangible Cultural Properties. The craftspeople chosen for this honour are selected for their artistic or historical significance. While many of them are potters, lacquer artists, bamboo workers, or swordsmiths, a substantial number are textile artists. Of the 22 nominated for this award in 1955,

no fewer than 10 were textile makers, of whom the majority were Yuzen dyers. Others have been added to the list in subsequent years, since many of the original group of Living National Treasures have died since the awards were established.

Two who represent the possible extremes are Kitagawa Heiro (1898–1988), so designated in 1956 and again in 1960, and Chiba Ayano (1890–1980), nominated in 1957. Kitagawa, who represents the seventeenth generation of textile artists of Tawaraya, was born in Kyoto. He is famous for his research into ancient textile techniques, studying old fabrics in the Shoso-in. He first was honoured for his revival of the silk gauze called *ra*, and later for his work in *yusoku orimono*, a material worn in court ceremonies since Heian times. Mrs Chiba, in contrast, was a simple peasant woman from Miyagi prefecture. She was a traditional folk artist who spent 50 years growing hemp, spinning thread, weaving cloth, and dyeing it with home-grown indigo. Kitagawa's expensive fabrics can be afforded only by the wealthy, while Mrs Chiba's cloth is traditional *mingei*.

Since Kyoto, especially the Nishijin district, has long been the centre of the Japanese textile industry, it is not surprising that the largest number of craftspeople honoured come from this city. Among the most famous is Moriguchi Kako, born there in 1909. Although his technique is the traditional one of Yuzen dyeing, his designs are new. He also follows the apprentice system and has his assistants live in his house for thirteen years, to get a spiritual as well as a technical education. The best-known textile artist from Tokyo is Shimizu Kotaro (1897–1988), who worked with paste-resist stencil dyeing, while Kamakura Yoshitaro (1897–1988) was honoured for his *bingata*-type cloth.

At the same time, a new generation of bold, highly imaginative designers have been creating a sensation in the

world of international fashion. Beginning in 1982, and especially in 1983, young Japanese fashion designers dominated the haute couture shows of Paris and New York. Their work indicates that the sensitivity traditionally shown in Japan toward textiles has not been lost, although it is now applied to very different garments. Several of the most outstanding of these designers have been active in Paris, including Issey Miyake (b. 1938), who worked with both Givenchy and Guy Laroche, and Kenzo Takada (b. 1940), who has his headquarters in Paris. However, as Kenzo has said, 'When I am in Tokyo, I feel French, but when I am in Paris, I feel Japanese.'

The most Japanese qualities of these new fashions are their use of subdued colours such as black, grey, and brown, expressing the *shibui* feeling ('astringent or unostentatious taste') so characteristic of the tea ceremony and of Zen Buddhism, the informal cut of the garments, which do not hug the body but wrap around it, and the use of typically Japanese fabrics such as rough wools, sometimes mixed with silk, all kinds of cotton, raw silk, and strange materials such as fishnet and paper. As *The New York Times Magazine* put it at the time of the Japanese arrival on the Paris scene, 'Either the Japanese movement is the most exciting thing to happen to fashion in years, or it's an outrage, a travesty of what clothes are supposed to be about' (Donovan, 1983).

Among the designers who created such a sensation during the 1980s are Kenzo and Issey, Yohji Yamamoto (b. 1944), and Rei Kawakubo (b. 1942), all of whom have shops in New York, as well as in Tokyo and Paris. The first of them to establish himself in Paris was Kenzo, who arrived there in 1965 when he was twenty-six years old, after graduating from the Tokyo College of Fashion. He had his first Paris showing in 1970. His work at once created a

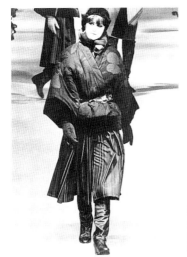

8.6 Jacket and skirt designed by Kenzo Takada (b. 1940), c.1980 (Photo used by permission of the artist).

sensation, with its baggy pants and oversized jackets, imaginative use of colour and patterns, and use of a wide variety of Japanese fabrics (Figure 8.6). The most conservative of the group, Kenzo has called himself a classic designer, intended for mature women who know their own style.

Perhaps the most influential of the new designers is Issey. Although he too worked for a time in Paris and has been showing there since 1972, he is still based in Tokyo. His earliest garments were made of *sashiko* quilted fabrics of styles originally worn by peasants and sumo wrestlers. Issey, however, cut the material more generously and adapted it to modern use, as he did the traditional *tanze* housecoat, which he turned into a hooded wool coat. Unlike Western clothes, his designs are not based on the human figure, but are very loose and built like a piece of clay sculpture. He talks of using the energy of the fabric, with the cloth taking on a life of its own. The cloth should work in easy collaboration with the body, he says, expressing his inter-

est in the feel of the garment against the skin and how the body moves within the space created by the clothing. His colours are generally subdued, but sometimes he uses bright red or pink for contrast. He favours striped and checkerboard patterns resembling traditional folk cloth.

The third of the celebrated male designers is Yohji, who studied in Paris in the late 1960s and began showing early in the 1970s. Although loose-fitting and often typically Japanese in their subdued elegance, his garments never have the bold theatricality found in some of Kenzo's or Issey's gowns. His coats and skirts tend to be long, as are his sleeves, which may extend over the hands like those found on kimonos (Plates 19 and 20). For kimonos, he has often chosen new, heavy-duty fabrics which give the garment striking visual energy. He also uses stripes, lozenges, and squares to give surface interest to his designs.

The boldest and most unconventional of the new designers is a woman, Rei Kawakubo. Unlike her colleagues, she was not trained in Paris but has lived and worked in Japan all her life. She once said, 'I do not find clothes that reveal the body attractive'. Her style is austere—black and white are her most favoured colours—and she speaks of 'getting down to the essence of shapelessness, formlessness, and colourness'. Like traditional Japanese clothes, her designs do not distinguish between male and female styles. She calls her shop *Comme des Garçons* (Like the boys), indicating that her casual garments can be worn by either sex. Her designs are often wildly unconventional, some with long broad sleeves like a *furisode*, or four sleeves which can be tied together, or uneven hemlines and unsymmetrical patterns. Among the youngest of the four, she is the most original and, at the same time, the most Japanese. Her work demonstrates that the heritage of classical kimono design is still very much alive in the late twentieth century.

Chronological Table of Japanese Historical Periods

Asuka period	AD 552–645
Nara period	645–794
Heian period	794–1185
Early Heian period	794–894
Fujiwara (Late Heian) period	894–1185
Kamakura period	1185–1333
Muromachi (Ashikaga) period	1333–1573
Momoyama period	1573–1615
Edo period	1615–1868
Meiji period	1868–1912
Taisho period	1912–1926
Showa period	1926–1989
Heisei period	1989–

Select Bibliography

General Sources on Japanese Textiles

Adachi, Fumie (1972), *Japanese Design Motifs*, New York: Dover Publications.

Buisson, Sylvie, and Dominique Buisson (1983), *Kimono: Art traditionel du Japon*, Lausanne: Edita.

Chamberlain, Basil Hall (1904), *Things Japanese* (4th edn.), Tokyo: Kelly & Walsh.

Conder, Josiah (1880), 'The History of Japanese Costume', *Transactions of the Asiatic Society of Japan*, 8: 333–68.

Dalby, Liza Crihfield (1993), *Kimono: Fashioning Culture*, New Haven: Yale University Press.

Donovan, Carrie (1983), 'Much Ado about the Japanese', *The New York Times Magazine*, 31 July, pp. 39–40.

Gunsaulus, Helen (1923), *Japanese Costume*, Chicago: Field Museum of Natural History.

—— (1941), *Japanese Textiles*, New York: Japan Society.

Hall, John C. (1910–11), 'Japanese Feudal Laws, III, Tokugawa Legislation Part I', *Transactions of the Asiatic Society of Japan*, 38: 269–331.

Hikida Keiichiro (1979), 'Snow and "Ramie Crêpe"', *Japan Quarterly*, 26(4): 539–48.

Kawakatsu, Ken'ichi (1936), *Kimono*, Tokyo: JTB Tourist Library, no. 3.

Liddell, Jill (1989), *The Story of the Kimono*, New York: E. P. Dutton.

Minnich, Helen Benton (with Nomura Shojiro)(1963), *Japanese Costume and the Makers of Its Elegant Tradition*, Tokyo and Rutland, VT: Charles E. Tuttle.

Murasaki Shikibu (1976), *The Tale of Genji* (trans. E. Seidensticker), New York: Alfred A. Knopf.

Murasaki Shikibu (1982), *Murasaki Shikibu: Her Diary and*

Poetic Memoirs (trans. R. Bowring), Princeton: Princeton University Press.

Noma, Seiroku (1974), *Japanese Costume and Textile Arts* (trans. A. Nikovskis), Tokyo: Heibonsha.

Tokyo National Museum (1954), *Pageant of Japanese Art*, vol. V, Tokyo: Tota Bunka Co.

Yamanaka, Norio (1982), *The Book of the Kimono: The Complete Guide to Style and Wear*, Tokyo: Kodansha.

Yamanobe, Tomoyuki (1957), *Textiles* (trans. Lynn Katoh), Tokyo and Rutland, VT: Charles E. Tuttle.

Yanagai, Soetsu (1936), *Folk-crafts of Japan* (trans. Shigeyoshi Sakabe), Tokyo: Kokusai bunka shinkokai.

Sources on Specific Aspects of Japanese Textiles

Adachi, Barbara (1973), *The Living Treasures of Japan*, Tokyo and New York: Kodansha.

Hayashi, Tadashi (1960), *Japanese Women's Folk Costumes*, Tokyo: Ie no Hikari Assoc.

Ito, Toshiko (1985), *Tsujigahana: The Flower of Japanese Textile Art* (trans. M. Bethe), Tokyo: Kodansha.

Kirihata, Ken (1976), *Kyogen Costumes:* Suo *and* Kataginu, Tokyo: Chuo Koronsha.

Issey Miyake, (1983), *Bodyworks*, Tokyo: Shogakukan.

Nakano, Eiko, and Barbara Stephan (1982), *Japanese Stencil Dyeing: Paste-resist Techniques*, New York: Weatherhill.

Nomura, Shojiro (1914), *An Historical Sketch of Nishiki and Kinran Brocades*, Boston: N. Sawyer and Son.

Rathbun, W. J. (1993), *Beyond the Tanabata Bridge: Traditional Japanese Textiles*, London: Thames and Hudson.

Shaver, Ruth (1966), *Kabuki Costume*, Tokyo and Rutland, VT: Charles E. Tuttle.

Tuer, Andrew (1967), *Japanese Stencil Designs*, New York: Dover Publications.

Catalogues of Collections and Exhibitions

Howell Smith, A. D., and A. J. Koop (1919), *A Guide to Japanese Textiles*, London: Victoria and Albert Museum.

Ishimura, Hayao, and Murayama Nobuhiko (1988), *Robes of Elegance*, Raleigh: North Carolina Museum of Art.

Nishimura, Hyobu, Jean Mailey, and Joseph S. Hayes (1976), *Tagasode: Whose Sleeves...*, New York: Japan Society.

Priest, Alan (1935), *An Exhibition of Japanese Costume*, New York: Metropolitan Museum of Art.

Rhode Island School of Design (1992), *Patterns and Poetry*, Providence: Museum of Art, RISD.

Stinchecum, Amanda M. (1984), *Kosode: 16th–19th Century Textiles from the Nomura Collection*, New York: Japan Society.

Tanaka, Yusaku (1961), *No Costumes of Japan 1573–1829*, Kyoto: Hirase Collection.

Tokugawa, Yoshinobu (with Okochi Sadao)(1977), *The Tokugawa Collection of Noh Robes and Masks* (trans. L. A. Cort and M. Bethe), New York: Japan Society.

Compendia of Illustrations of Japanese Textiles

Blakemore, Frances (1978), *Japanese Design through Textile Patterns*, New York and Tokyo: Weatherhill.

Harada, Jiro (1932), *English Catalogue of Treasures in the Imperial Repository, Shosoin*, Tokyo: Imperial Household Museum.

Textile Designs of Japan (1959–61), Tokyo: Textile Design Centre.

Uemura, Rokuro (1949), *Old Art Treasures from Japan's Needles and Looms* (trans. Shiho Sakanishi), Kyoto: Koinsha Co.

Verneuil, Maurice P. (1910), *Étoffes Japonaises tissées et brossées*, Paris: Librairie centrale des Beaux-Arts.

Index

73